Norman Thomson

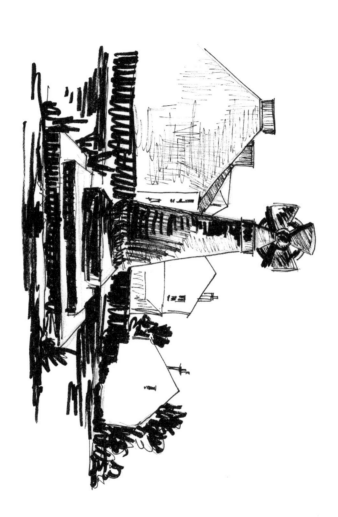

PAINTING ᴛʜᴇ BRITISH ISLES

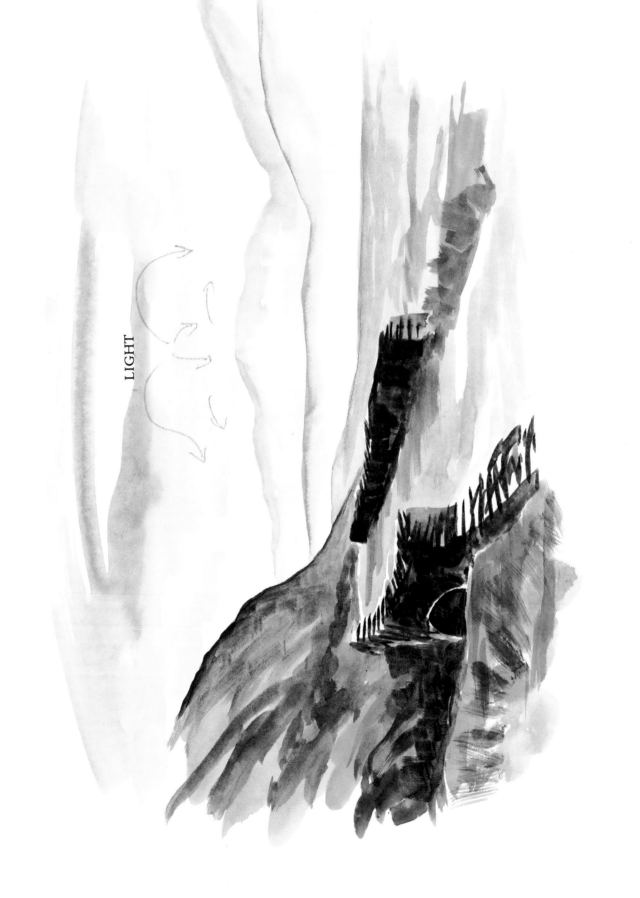

LIGHT

PAINTING THE BRITISH ISLES

A WATERCOLOURIST'S JOURNEY

Ashley Jackson

B�XTREE

I dedicate this book to my eldest daughter, Heather, who has patiently accompanied me the length and breadth of Britain on my water colourist's journey.

First published in Great Britain in 1994 by Boxtree Limited

Text and illustrations © Ashley Jackson 1994

The right of Ashley Jackson to be identified as Author of this Work has been asserted by him in accordance with the Copyright, Designs and Patents Act 1988.

1 3 5 7 9 10 8 6 4 2

Cover and text designed by Maggie Aldred
Typeset by SX Composing, Rayleigh, Essex
Printed and bound in Portugal by Printer Portugesa for

Boxtree Limited
Broadwall House
21 Broadwall
London SE1 9PL

A CIP catalogue entry for this book is available from the British Library.

ISBN 1 85283 468 4

Front cover photograph © Mostafa Hammuri
Back cover illustration © Ashley Jackson

CONTENTS

ACKNOWLEDGEMENTS

I would like to thank Susanna Wadeson and Penny Simpson for all the help and encouragement they have given to me with the editing of this book. I would also like to thank Heather Jackson: without her help and enthusiasm this book would not have come about. A special thanks to the following tourist information offices who have been unbelievably helpful and generous with their time: Bury St. Edmunds; Betws-y-Coed; Ballachulish; Coniston; Cheddar; Guildford; Nelson; Portree; Seahouses; St. Ives; Sherwood Forest; and Whitby.

INTRODUCTION

The British Isles, to my mind, is the greatest 'undiscovered' land in the world – by its natives, that is. Visitors from abroad seem to know more about our landscape and history than we, the inhabitants, do. In this age of foreign travel, when so many of us holiday abroad, we often do not take the time to discover the British Isles for ourselves. I have designed this book to be a journeyman companion for you, as you discover for yourself picturesque areas of the country which you may never have known existed.

You will find that this book simplifies the art of landscape watercolour painting, but the challenges that you and your palette will discover on our travels are numerous. From the quaint, typically-English village of St Ives with its brightly-painted houses and colourful harbour to the dramatic, often awesome sights and moods that you will experience in Glen Coe, in the Scottish Highlands, the journeys that I take you on will give you experience of many different facets of working in watercolour.

On journeying across Britain, capturing all corners of these islands on watercolour paper for the purposes of this book, I was stunned to find just what an oasis of colour and contrasting contours, with its spectacular atmospheric views, it is. I hope that this book will not only inspire you to paint more and capture some of the magnificent scenery that we are honoured to have on our doorstep, but that it will help you, as my journey helped me, to really appreciate the British Isles, her landscapes and her many moods.

Only through being out in the open air, or 'Mother Nature's garden', as I prefer to call it, can we really appreciate the beauties of nature which are on our doorstep. Hear the skylarks calling, feel the wind blow through your hair and the heat of the sun on your skin, witness the drama of the constantly changing light and moods of the countryside; these elements of nature build up to form a most memorable picture in our minds, stored away for only ourselves to see. How many of you have said on one of these occasions, though, when the beauty of a particular view has sent a shiver down your spine, 'If only I could paint it, then I could capture this moment in time forever'.

This book will help you to capture those moments, however basic your experience of landscape painting, on watercolour paper. The whole purpose and meaning of painting is to be able to transmit what you see and how you feel on to paper, so as to convey your feelings at that particular moment to others. I hope that I will be able to add to your enjoyment of the landscape, by giving you the ability and confidence to paint and record it for posterity, enabling you to relive the experience every time you view your work.

The problem with painting whilst on a journey is that artists seem to carry with them the same

palette as they use at home, which is the one that they are familiar with. What they tend to forget is that the colours of nature change across the country, due to the varying pigments in the earth, and the artist needs to adapt his or her palette to match. I too encountered this problem, having spent most of my life as an artist painting and capturing the Yorkshire Pennines, and my solution is to use a limited palette. This may sound surprising, but I have found over the years that a palette can be used to harmonize with different locations far better than a 'box of many colours' containing a huge variety of shades. I have always strived to simplify what I see by using not more than four or five colours and sometimes only three. After all, there are only three primary colours, red, yellow and blue, but remember that it is the varieties of these colours that you have to learn to handle.

To my mind, watercolour is the ideal medium for painting the landscape of Britain: wherever you go, you are never far away from water, and the colours of water, blues and greys, are everywhere around you. Because of this, the predominant colour in the landscape is a blue light.

To gain the true feeling of location, it is vital to use your senses of smell and touch to soak up the atmosphere of the area, so that you feel at one with your surroundings. Then and only then will your painting convey to others your emotions at the time of painting. I recommend that in each of the areas you visit, you dig up a clump of grass and allow it to dry out: in this lump of grass and earth you will see every colour you will need in your palette to capture the scene, as every colour

in the landscape will be there. Remember that most of the buildings around you will also be made of local materials, and so their colours will come from the same palette.

You need to identify the predominant colour in any landscape, and having identified this 'key colour', you should then use it in every area of your painting. If your key colour is that of the sky, the same colour has to be added to every part of your landscape, but sparingly, like a pinch of salt to food. Then and only then will your whole landscape harmonize and this is important in order to be able to create atmosphere in your work.

You will encounter many problems relating to painting on this journey, but I hope that through this book and with the help of what I call my artist's companion, *A Brush with Ashley*, I will be able not only to prepare you for the problems you will encounter, but also to give you the solutions to these problems, and ensure that your painting journey across Britain is a totally fulfilling and enjoyable one.

My aim is that when you have read and practised the contents of this book, you will emerge not as an Ashley Jackson 'clone', purely copying my style, but as an artist who can convey and produce your own individual feelings and experiences in your own style in watercolours. After all, if we were all the same, the world would be a very boring place in which to live.

If you enjoy this tour of the British Isles half as much as I have done, you really will have a wonderful experience capturing our beautiful country on watercolour paper.

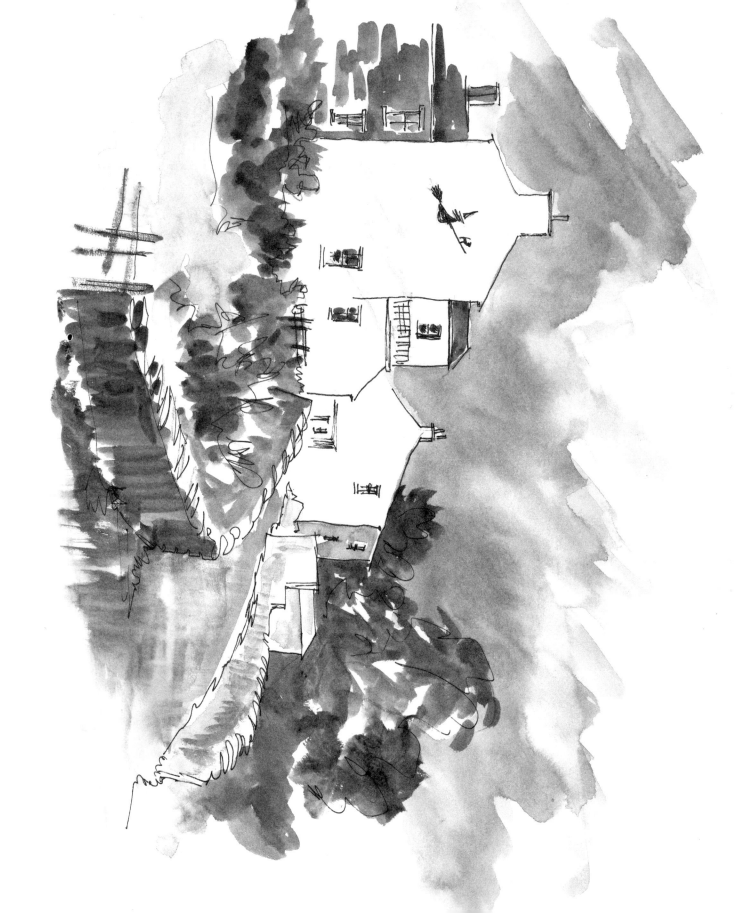

GLEN COE

Many people believe that I am a Yorkshire-born artist. This is not true; Yorkshire is my adopted county. I was born in Penang, Malaysia, where my father was in British Intelligence. During the Second World War, my whole family excluding the menfolk were evacuated to Bridge of Weir in Scotland. I was six at the time, and I still have many fond memories of paddling in the beautiful Loch Lomond which was not far from where we were staying. I was in Scotland for a year before going back to South East Asia. I believe to this day that it was these remembered images of Scotland which inspired me to capture my visions in watercolour with the melancholy and romantic feeling that I hope they convey.

O n my return to Britain at the age of ten, my home became Huddersfield in Yorkshire, in the heart of the Pennines. Yorkshire, as I have said, became my adopted county, but I have always had a soft spot for Scotland, and I felt this was the ideal opportunity, on my way north to the Isle of Skye, to rekindle some of those burning images of the Highlands that I hold in my mind's eye.

I started my journey from Glasgow on the A82. The road skirts round one of Scotland's most

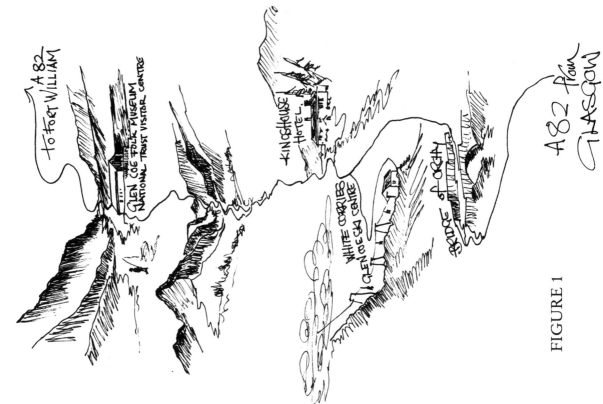

FIGURE 1

beautiful lochs – the one I used to paddle in, Loch Lomond. You will find that your journey will take much longer than it should because you will want to stop and admire each different spectacular view that you discover on your way. The piercing mountain-tops with their haloes of cloud that surround the Loch, and the furry shoulders of trees dipping into the Loch-side truly make a fascinating picture.

Keeping on the A82 you traverse the Bridge of Orchy, as can be seen from the map (*Figure 1*). On this day I was heading for Glen Coe where on 13 February 1692, on the orders of William III, nearly forty members of the Macdonald clan were massacred for their Jacobite sympathies, and their delay in taking the oath of allegiance to William. Whenever I am in the Highlands, I try to visit this glen. There is something that draws me there and gives me a shiver down my spine. Whether this is due to chilling thoughts of the grim history of the glen, or just the sheer, barren beauty that is awe-inspiring and entices me there, I do not know.

I prefer to go in the early spring or the late autumn, for then I do not encounter today's enemy – the midges. It is often impossible to concentrate with these kamikaze pilots distracting you. The draw-back is that you miss the sight of the wonderful heather-clad Highlands if you visit after the midges are gone. It is worth being bitten if you have never experienced Scotland in heather before.

Reaching White Corries, the Glen Coe Ski Centre, and using the ski chair, I was able to get a bird's eye view of this most attractive glen from the summit, without having to use my legs! *Figure 2* was created at the summit. I was captivated by the low cloud hovering around the mountain-tops and I sketched it rapidly with a 4B pencil and putty rubber. I created the highlights in this sketch by purely rubbing out, using my rubber to pull out, as I would with my moist brush if I were painting.

I love tonal drawing. I am not as attracted to outline drawing as I feel that this technique tends to turn the landscape into a cartoon picture, instead of creating a depiction that has depth, feeling and atmosphere for the viewer to appreciate.

As I was wandering above White Corries I heard the sound and movement of water. Curiosity drew me to the source of a mountain beck, or burn as it is known in Scotland. I could not find my pencil, but whilst searching in my pockets, I discovered a piece of conte crayon. Rummaging in my pockets reminded me of my days as a young schoolboy when I could find everything bar the kitchen sink in my pockets; if nothing else, there was always a sticky boiled sweet with fluff all over it!!

Using this piece of conte crayon, I started to paint in the scene before me. I always try to refer to this technique using a pencil, as 'painting in' rather than drawing, because to draw with a pencil immediately conjures up images of outline drawings. When I use the term 'to paint in with a pencil', an image of tonal value and depth is automatically created, and there is no confusion about the effect that I am wanting to create.

Due to the mist and moving rain in the area, I

was chilled to the marrow, and the lightning sketch, *Figure 3*, took me no more than three minutes to do. As I have said on many occasions, it is good practice to set yourself a time limit, whether painting or sketching, as you will find it prevents you from creating a composition with too much waffle in it. In other words, you only have time to put what you really want into your picture; you have no time to add in all the little after-thoughts that more often than not will spoil your final result.

I made my way hastily to the ski-lift. As you will discover for yourself, the moods of this mountainous region seem to change every second, and I felt that I had to capture in *Figure 4*, again using my conte crayon, the sight of moving cloud above Glen Coe.

I almost forgot for a moment that all my readers may not be familiar with conte crayon. Conte crayon is a square stick of hard pastel, available in all the earth colours, Burnt Sienna, Burnt Umber and black and white. However, on this particular day I used Burnt Umber. I tell my students that they should treat and use the crayon that they are working with like the side of a lead pencil. As it is longer than the lead of a normal pencil, about 2½in (6cm) long, you will be able to put the crayon flat on to the surface of your paper, and easily pick up its soft textures. *Figure 4* clearly shows what I mean – the lovely textures on the mountainside have been achieved by the surface of the paper and the crayon itself. The light and dark tones of your subject can be achieved through the pressure that you exert on the paper. I seldom use the ends of the conte crayon, but work purely with the sides of it, and this allows me to easily 'paint' with it.

In the glen itself, I started to wander away from the roadside to see if I could find a suitable location to capture this beautiful landscape on my watercolour paper. I wanted to convey to a viewer that I had become totally absorbed by this huge expanse of land which I thought looked like a huge resting mammal.

When I came across this composition (*Figure 5*), the light was coming in from my left, and I marked it down with my directional arrows. I quickly got a rough outline of what I wanted. However, there was something about this composition that did not appeal to me, but I could not put my finger on it, so I persevered. My next stage was to paint in my composition with my 4B pencil in *Figure 6*. Note that I did not use my rubber in this one. In the previous pencil figure, I created the sharps by rubbing out, in this one I put the darks in first, leaving the whites and lights to take care of themselves.

At this point, I started to feel ravenous, and dug deep into my rucksack for my sandwiches and hot, homemade soup. The soup thawed me out. As I sat, tucking into my sandwiches, watching and admiring the light changing across the glen, I realized what it was that had been niggling me about the composition – it was the light.

When I had first sat down, the light had been coming from my left, but as it moved round to the right, it hit the valley bottoms and the mountainside, instead of just the right-hand side of the glen.

FIGURE 2

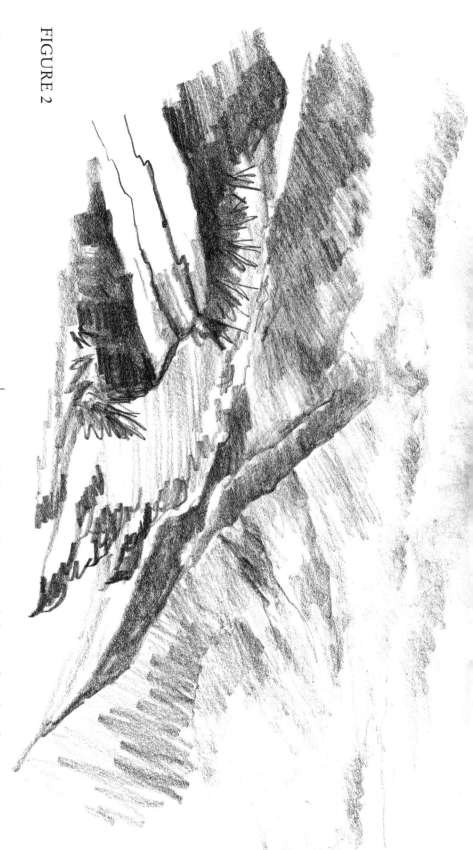

The whole view in front of me seemed to be coming alive.

I tell students to capture a moment from the time they start to draw, the direction of light included, but this was an exceptional case. To change my directional arrows of light would be to enhance the painting; the photograph of the glen shows how it was now truly alight with colour and shape.

As soon as I got this help from mother nature, and felt the atmosphere she created, I was ready for the challenge of painting Glen Coe. Because I

knew all the past history and drama that the glen holds, I wanted this painting to capture the drama and majesty that I felt as I stood there.

While I was drawing in the composition very lightly with my 4B pencil, I knew luck was on my side. The same magnificent cloudscape that I had witnessed at White Corries was now moving across the glen.

Painting in the sky with a grey wash, the mixture being made up of Ultramarine Blue, Prussian Blue and Burnt Sienna with a pinhead of Crimson Alizarin, I then pulled out the highlights in the

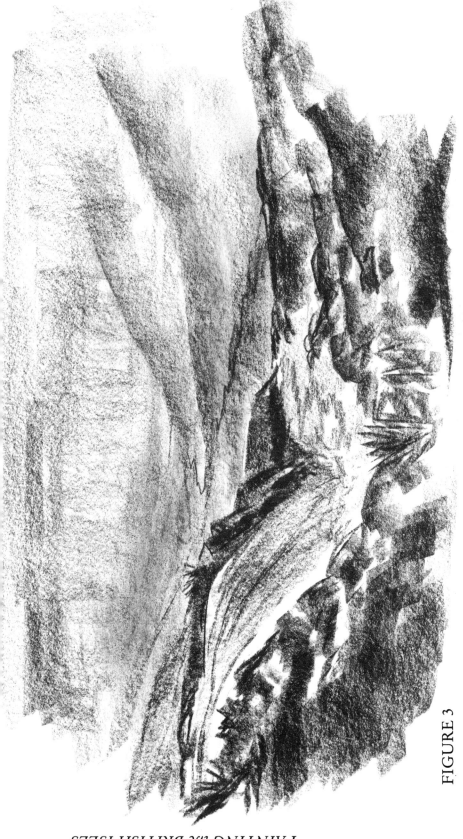

FIGURE 3

sky with a moist brush. While I waited for the sky to dry, I tinted in the background mountains, moving towards the foreground with my sky mix, but not forgetting to leave out the all-important lights.

I then went back to the sky to put in the heavy dark cloud. I used the same colour mix as previously, this time making it a little stronger by adding some more Prussian Blue. Bringing down the same strong cloud colour, I washed in the darks of the background mountains and fore-

ground, shaping them in with light and shade.

Then, with Raw Sienna and Lemon Yellow, I tinted the majority of the lights in the painting, although I left some patches of white, so that your eye is led into the picture.

There were some pools of water in the foreground and middle distance which reflected the light from the sky. The pools of water in my painting were created by using the first sky wash colour. Now I was starting to get really involved with the shape of the foreground mountain which

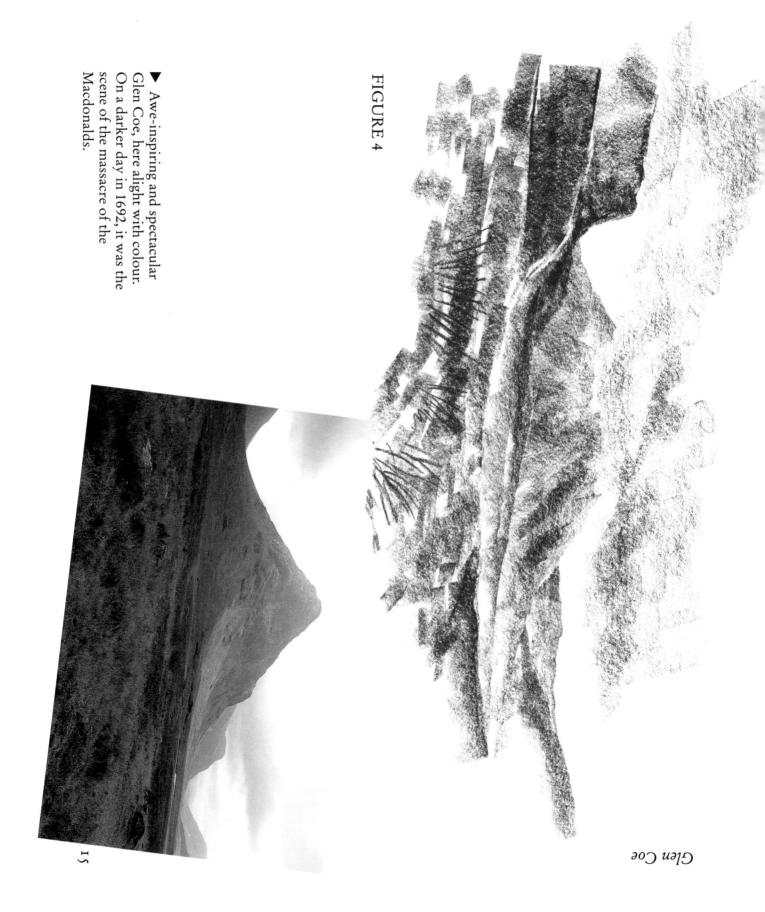

FIGURE 4

Glen Coe

▼ Awe-inspiring and spectacular Glen Coe, here alight with colour. On a darker day in 1692, it was the scene of the massacre of the Macdonalds.

15

LIGHT

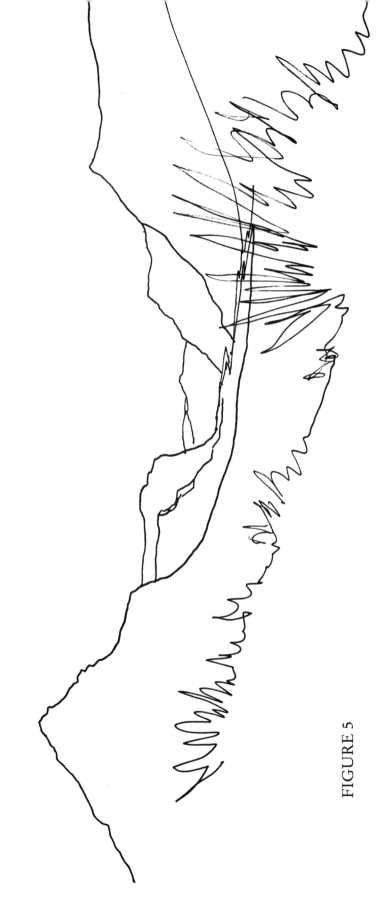

FIGURE 5

sat there like a great emperor on a throne of rock. I gave this mountain two more washes of the dark cloud colouring, coming forward to the darks in the foreground. I always put the darks in first, as I feel then that the lights will take care of themselves. For this painting I used two large sable brushes, numbers 10 and 14, and a dry $1\frac{1}{4}$in (31mm) chisel edge brush which I later used to achieve the blades of bracken and tufts of grass.

The bracken was a really rich colour at the time of year I visited the area. A good tip regarding colour mixing and to help you get to grips with the colour of the earth is to dig up a grass sod. Take this home with you, and try to capture all the colours that you see in it. As it is drying out, over a period of a few days, keep painting the colours that you see, and you will have created nearly every seasonal colour that you require. Remember though that different regions will have different pigments in the soil, and these will have

different colours in them. However, by the time you have finished this exercise, you will no longer be intimidated by colour mixing, and will really begin to enjoy the art of watercolour painting.

In the foreground and middle distance of the painting is the shadow of a dramatic cloud in the sky on the landscape. This shadow helped me to shape the painting as it allowed the eye to travel into the glen. In this painting of Glen Coe (*Figure 7*) there are no man-made objects. It is a painting

that simply captures the beautiful landscape and atmosphere. It is important to note that 90 per-cent of this painting was achieved by the technique of wet onto wet; this means that I put one wash on the surface of the paper and did not give it time to dry before adding a second wash. This technique, you will find, fuses the colours together. Wet onto wet is the best technique to use when painting out in the open air, especially in Britain where nine out of ten times the atmos-

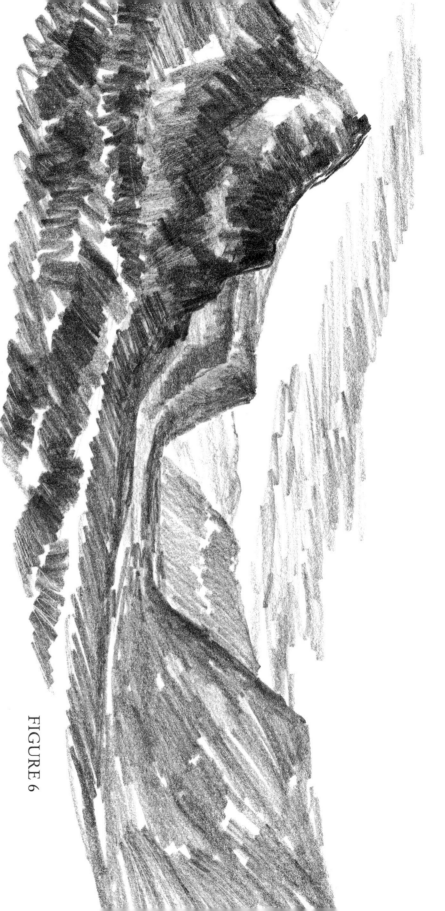

FIGURE 6

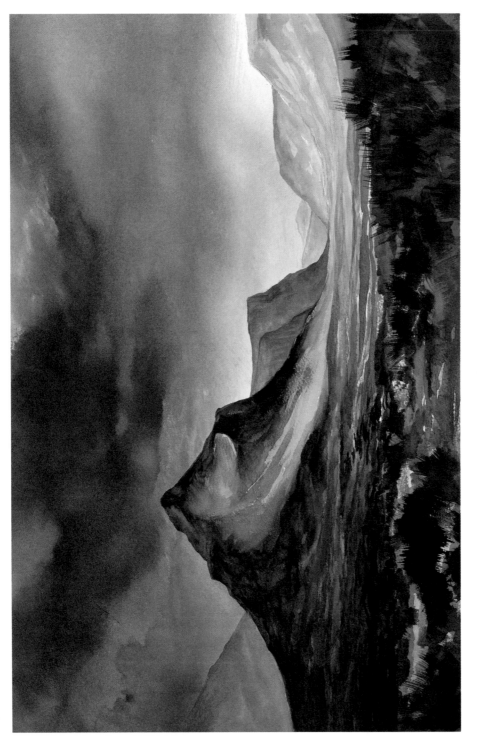

FIGURE 7

phere is damp rather than dry. The other 10 per-cent of my painting was achieved by what I call a dry technique. This I used in order to shape my subject, by adding a wash or washes where the surface of the paper had been allowed to dry. With this process no fusion occurs, and I use this technique to add finer details such as bracken or blades of grass. Think of the 90% of washes as being like a boot, and the 10% as the laces, the bit that pulls the whole thing together.

I had been totally absorbed by the glen, and have titled my painting 'The Macdonalds' Glen – Glen Coe', a homage to the forty men who were massacred in this awe-inspiring, spectacular glen.

ISLE OF SKYE

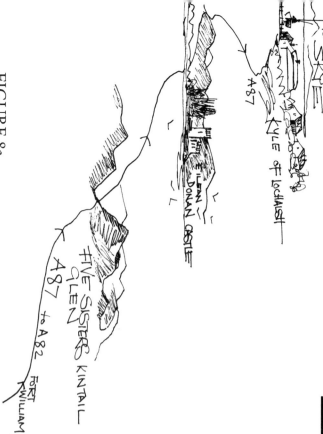

FIGURE 8a

Leaving my beloved Glen Coe behind me, and passing through Fort William on Scotland's A82, which then joins the A87 to the Kyle of Lochalsh, I headed towards the Isle of Skye which was to be my next destination.

On this route, the northern road to the Isles, I passed through some of the most picturesque and romantic landscapes that one could ever wish to see. I momentarily imagined myself to be back in the eighteenth century when Bonnie Prince Charlie hid there while fleeing the Hanoverian forces.

I travelled through the Glen of Five Sisters, which is called Glen Shiel, on to the Bridge of Orchy. The countryside reminded me of Banff in Canada with its fir trees reaching high into the clouds. I imagined them to be like the Hanoverian troops, standing straight and tall as they marched in line in search of the vanished prince.

The road journeyed around Lochalsh, passed the lovely castle of Eilean Donan which you can see on *Figure 8a*, on to the Kyle of Lochalsh to meet the ferry. The short journey time – around twenty minutes – means that the ferry runs quite regularly to the Isle of Skye. The journey for Flora Macdonald and Bonnie Prince Charlie I am sure took considerably longer when in 1746 she took him 'over the sea to Skye', where he hid until he finally made his escape to France.

Figure 8b shows my journey 'over the sea to Skye', crossing the mouth of Lochalsh, and passing a wonderful lighthouse on an island with the range of the Scottish mountains behind it.

On reaching the little town of Kyleakin, I felt as though I was one of the little people from *Gulliver's Travels*. The gaily painted cottages were dwarfed by the mountains of Skye, in particular the Cuillins which I was heading for, as can be seen in *Figure 8c*.

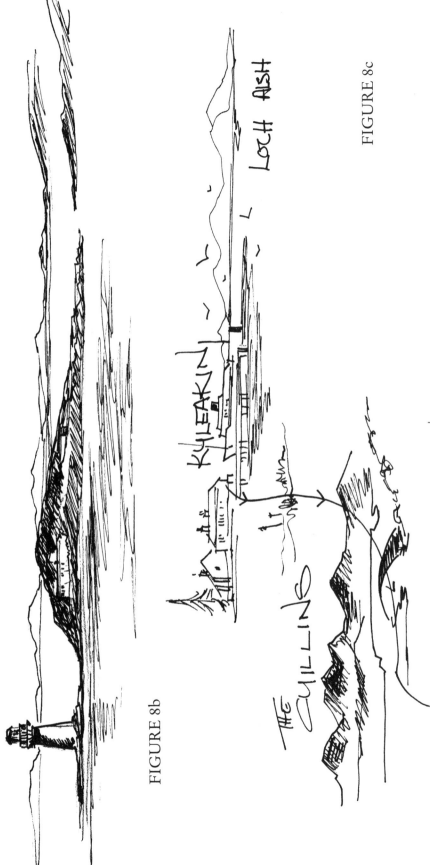

FIGURE 8b

KYLEAKIN Loch AISH

THE CUILLINS

FIGURE 8c

ing, is to be able to convey the feeling to the view-
er that the picture was conceived on totally flat
land and that the mountains in the middle dis-
tance actually did push up into the sky with all
their energy, that they were real. If not executed
correctly, the final painting can look as if the
mountains have been stuck on as an afterthought.

In order to be able to capture this properly, you
must grasp the art of perspective and understand
eye-level line. Eye-level line is an imaginary line

I could not wait to put pen to paper in the sheer
excitement of being at the foot of those magnifi-
cent sculptures, the Cuillins. I sketched an outline
composition of the Cuillins with my drawing pen,
Figure 9. Then I could not help but do a second
one, *Figure 10*, with my 4B pencil, giving me a
tonal value and depth of scenery on paper. These
practice runs or studies are a good exercise that I
recommend for the student.

One of the most difficult things to do in paint-

FIGURE 9

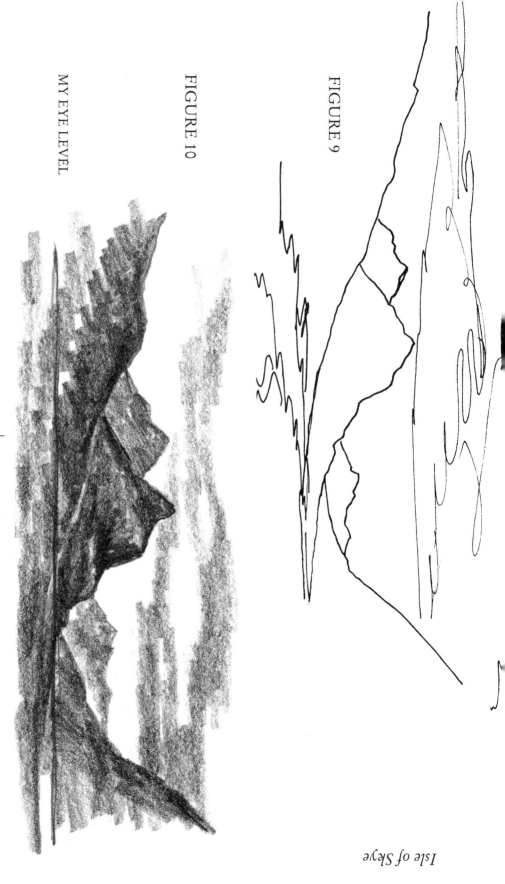

MY EYE LEVEL

FIGURE 10

in the far distance which goes straight across the view that you are looking at. To find it you must look straight ahead into the distance, and your eyes must not look up or down. When you stand up, your eye-level will go up with you and when you sit down it will go down with you. Treat it like a slipped halo, it's more fun that way! When composing your painting i.e. drawing it in, remember that any horizontal line which is above the eye-level line will come down to meet it and any horizontal line below goes up to meet it.

This composition is a good example of why you cannot call your eye-level line a horizon line. The horizon line is where the mountains meet the sky and your eye-level line is totally different. The only time that your eye level line and the horizon line are the same is when you are out at sea or in flat countryside.

On my way to the Cuillins, I came across this magnificent bridge, built to withstand all the

Isle of Skye

21

FIGURE 11

elements and tempests that this mountainous area could sling at it. I could not help but 'paint it in' with my conte crayon in *Figure 11*. I chose the conte crayon as I wished to create on paper the soft and velvet-like textures that were before me. The texture of the cartridge paper helped to create the velvet appearance that I so desired, and I was easily able to capture the light and shade that I required for this very simple figure.

I was dressed as always for all seasons. Although Britain is a fine and beautiful country, it is not unknown for a travelling artist to experience four seasons in one day! I was lured away from the car by the sound of rushing water. Discovering its source in a stream, I was con-

fronted by that family of mountains, the Cuillins, right before me – an awesome sight for anyone's eyes.

This without a doubt was going to be where I dipped into my rucksack to get out my watercolours and 30 × 20in (76 × 50cm) rag paper in order to create *Figure 12*. Clipping the paper to a board, I proceeded with a very rough pencil outline of the scene. I was going to paint my painting using a very limited palette of colour: Prussian Blue, Burnt Sienna and Cadmium Yellow.

From the photograph of the Cuillins you can tell that a very damp atmosphere surrounded me, and that the light drizzle which was falling was creating a heavy dew on my paper. Because of

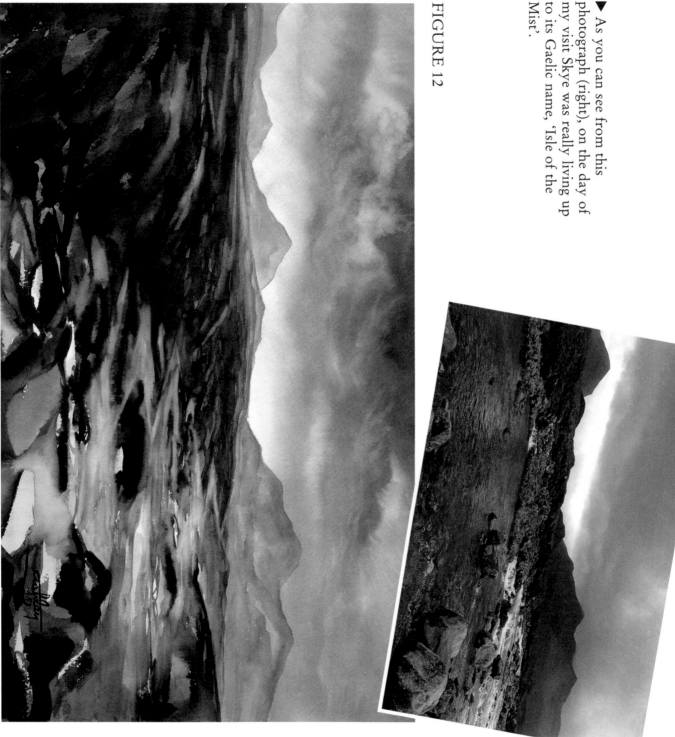

▶ As you can see from this photograph (right), on the day of my visit Skye was really living up to its Gaelic name, 'Isle of the Mist'.

FIGURE 12

this, I had to work the majority of this painting with the wet on to wet technique, applying a second wash before the first had dried. However, the mountains in the distance are quite sharp, and those alert ones amongst you will be thinking, how did he achieve that using a wet on to wet technique? The answer is that the mountains in this case were created first with a dry brush. The mixture for the distant mountains was Prussian Blue and Burnt Sienna, which when mixed properly, gives the impression that Crimson Alizarin has been used instead of Burnt Sienna.

Next, I made the sky area moist by applying clean water to it with my wash brush, leaving a halo of dry paper around the mountains so they did not fuse into the sky. That would have defeated the object, as the mountains at this point were still wet. My cloud wash was a mixture of Prussian Blue and a little more Burnt Sienna with Cadmium Yellow, creating a feeling of Burnt Umber.

Painting in the sky area with this wash, I then cleaned my wash brush thoroughly in the stream beside me, and pulled the brush head through two fingers holding them in a scissor-like manner. They act as a mangle and disperse surplus water in the brush, while leaving it moist. I was then able to mop out the light areas to form the clouds in my now dramatic sky.

Using a little bit of the background mountain colour, I put in the stream, bearing in mind that the colour was going to run and fuse in with any other colour that I used as the paper was damp. I then mixed Prussian Blue with Burnt Sienna to form the colour of the rocks in the water. Painting these directly on to the paper, they immediately began to fuzz. I quickly washed out my sable-pointed brush and, using it dry, reshaped each rock, creating the highlights I so desired. I dropped in the dark side of the rocks with the same wash I had used previously, but added a little bit more Prussian Blue to it, this giving me some sharp areas already in the painting.

The wet on to wet technique was the ideal technique to use for the river regardless of the weather; because of the fusion that occurs it creates a feeling of damp and misty water. If the day had been dry, and I had waited for each of my washes to dry, I would not have captured the watery effect.

I put in a mixture of Prussian Blue, Cadmium Yellow and a little touch of Burnt Sienna as a weak wash for the background of peat and bracken banks, before working towards the foreground of the banks gradually using a stronger mix – in other words, less water and more colour.

I observed the lights and contours of these banks, and used a moist, pointed number 10 sable to draw in the contours, leaving no hard edges but soft lines in order to create the boggy atmosphere of the landscape, the painting of which I have titled 'Watershed'.

I had been so engrossed in my work that I had not realized until I began to put away my brushes, just how sodden, wet through and cold I had become. However, the thought of tasting a 'wee dram' of one of the Isles' famous whiskys soon warmed me.

HOLY ISLAND – LINDISFARNE

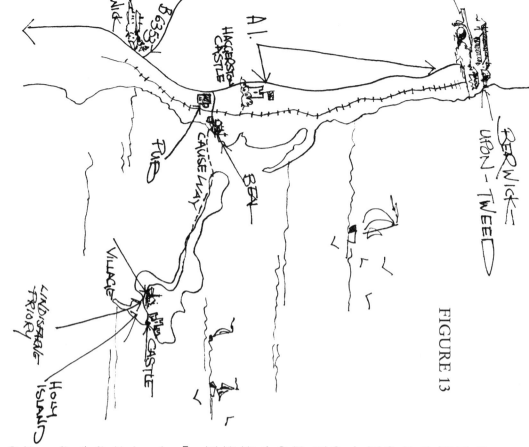

FIGURE 13

One of the most beautiful coastlines of Britain has to be that of Northumbria, with its wild, rugged, windswept and totally unspoilt beauty. Its contrasting scenery – the round, undulating Cheviot Hills, the flat coastline, the medieval castles of Bamburgh, Hageston and Lindisfarne, to name but a few – surely make it an artist's haven. Here, one can capture the wild, forbidding and dramatic beauty of this county, and paint miles of golden sand, knowing there will not be a deckchair in sight. The coastline provides us with scenery that one can look across at and imagine that it would have looked the same in the days of Bonnie Prince Charlie and the Duke of Cumberland.

I decided to head for Holy Island, a place that I hoped would provide me with superb subject-matter. I love painting skies and I wanted to create a painting with the contrast of a bleak and somewhat barren island set against a large, powerful and awesome sky.

This island was first known as Lindisfarne, a name which, it is believed, originated from the Celts, as *Lindis* is the name of a nearby stream and *fahren* is a Celt word for a place of retreat. It was on this island that the *Lindisfarne Gospels*, one of

FIGURE 14

the finest works of art of the Dark Ages, was produced by the monks who lived there. The monastery on the island was abandoned in AD875, but two centuries later it was refounded and the island renamed Holy Island.

As you can see from *Figure 13*, the map, travelling down the Scotsman's road from Berwick or up from Newcastle on the A1, you will see the signs for Holy Island as you approach Fenwick. At the Plough Inn, take the road signposted Holy Island. You will then travel through the picturesque village of Beal and down a long and windy single-track road to the causeway which will take you across to Holy Island. Before embarking on your journey I should enquire with

the Berwick Tourist Information Office as to the safe times for crossing to the island. You would not wish to be trapped by the high tide. If you do as I did though, and go without thinking, you may have to rely on the times displayed at the beginning of the causeway, and you could be in for a long wait.

On this day luck was on my side, the tide was just going out, and a sight met me that I would recommend anyone to witness. Arrive at high tide and see for yourself nature at work, her beauty and sheer power as she pulls the water back, unveiling green algae glistening on the rocks, followed soon after by the causeway itself.

There is a lookout box on the causeway, but I

prefer to call it an escape ladder for fools like myself who get carried away with painting the scene, only to find that our boots are beginning to fill with water as the tide rapidly returns. I had to sketch it with my 4B pencil, *Figure 14*, trying to capture people's feeble attempt to fight the elements. Then I began to zig-zag across the strewn seaweed and drifting sand until I came across some standing poles which moments earlier had been submerged and hidden by the sea. These poles mark the 'Pilgrim's Way', the footpath across to the Island, for the more energetic ones! As the sea drew back they emerged like Arthur's sword Excalibur from the water. Only a few seconds after the standing poles appeared, the scav-

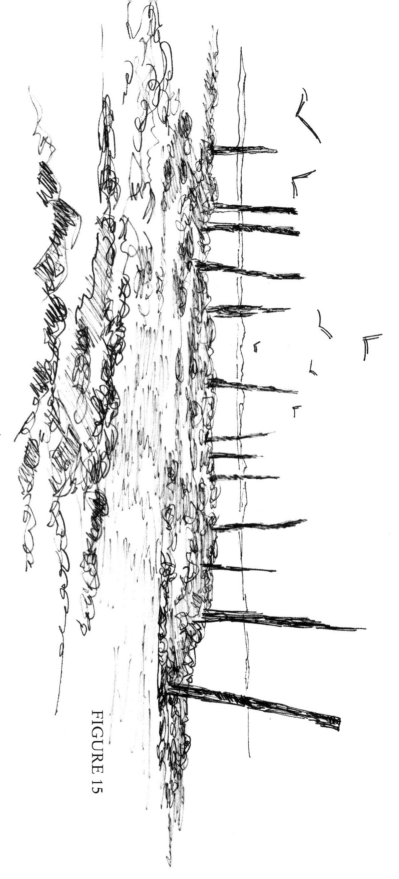

FIGURE 15

engers of the air arrived to pick and clean the causeway of its natural debris. I found the vision before me most eerie.

Painting landscapes is all about the messages that one gets from the earth, wind and fire, the natural elements on this earth. All artists must carry this thought with them at all times in order to be able to convey atmosphere in their work. It is for this reason that I feel it is an honour for me to be an artist and I hope that this momentary experience is conveyed to you in my pen sketch, *Figure 15*.

Much of the island is lent to the Nature Conservancy Council, so you will find that there is an abundance of wildlife ranging from a wide

27

variety of wild flowers to many species of wildlife. This island is not only attractive to artists but to birdwatchers as well. I could not help but hear the songs of the puffins, kittiwakes, terns and waders as I was drawn towards the island.

Holy Island, as I explained earlier, is historically known as Lindisfarne. It was the missionaries from Iona led by Saint Aiden who first built a monastery here in 634. Whilst visiting the Priory with its large domed arches which frame the moving skies of the Northumbrian coast, and walking through the village, I discovered a Celtic cross on the village green, *Figure 16.*

As an artist you will find that you become very observant. When I was strolling around I noticed that there were no tall buildings, although the majority were two-storey. They looked like large whitewashed bungalows, and gave me the momentary feeling that I was in Cornwall, miles away in the south. The raw edge of the chilling wind soon brought me back to the reality of northern Britain.

I made for the castle because I have always had a romantic yearning to capture in watercolour all the castles of the uplands of Britain. You can see this one from the mainland majestically piercing the North Sea sky.

On approaching the castle, where many lives in days gone by were lost in trying to conquer it, I imagined the white gulls hovering above me turning into ravens as an eerie light passed over. I felt as though I was being drawn to the walls to save a maiden, and it was for this reason I called the castle 'Rapunzel's Castle'. I captured the vision

before me rapidly on cartridge paper using French Ultramarine, Burnt Sienna, Cadmium Yellow and Prussian Blue, trying in *Figure 17* to portray the feeling and atmosphere that was beginning to touch my soul.

The composition of the castle with its seascape that I chose to paint can be seen in *Figure 18.* It is an L-shaped composition, but on observing it more closely you will note that it is led in by a letter C, which is the formation of the water against the peninsular of the land. Perspective in this work is helped on by the standing poles of the Pilgrim's Way rising from the rock. This you will find, enables your eye to be led easily into the picture and gives the true size and scale of the castle in the distance.

I wanted the castle and the hill as a silhouette against a dramatic sky. It is the sky that you tackle first once your drawing is complete. This one was a difficult one, a true challenge: it was dramatic, dark and overcast. I achieved it by wetting the sky area with clean water which I applied with the wash brush. Then I put on a mixture of Ultramarine Blue and Prussian Blue with a touch of Alizarin Crimson, like a horizontal band at the top of my painting. I then quickly mixed together Lemon Yellow and Burnt Sienna, which gives the feeling of Raw Sienna, and put a band of this mix below the blue, so it looked at first glance like a flag in the sky. Working fast with a moist brush I pulled out clouds and shaped the sky, giving the glow that I desired.

Algae grows in shaded and damp areas. I have always loved to paint it on the trees and walls of

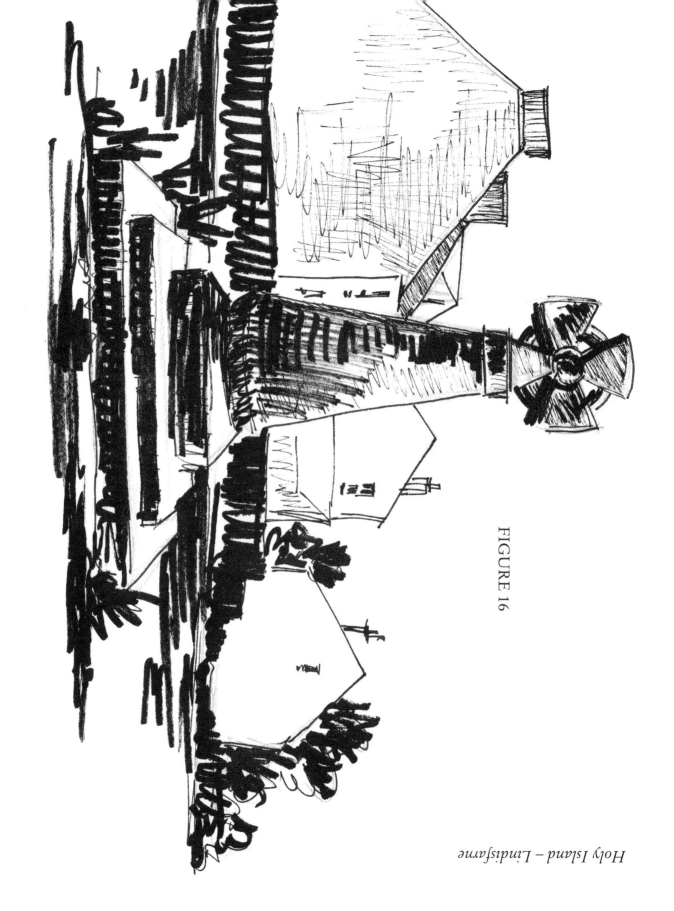

FIGURE 16

Holy Island – Lindisfarne

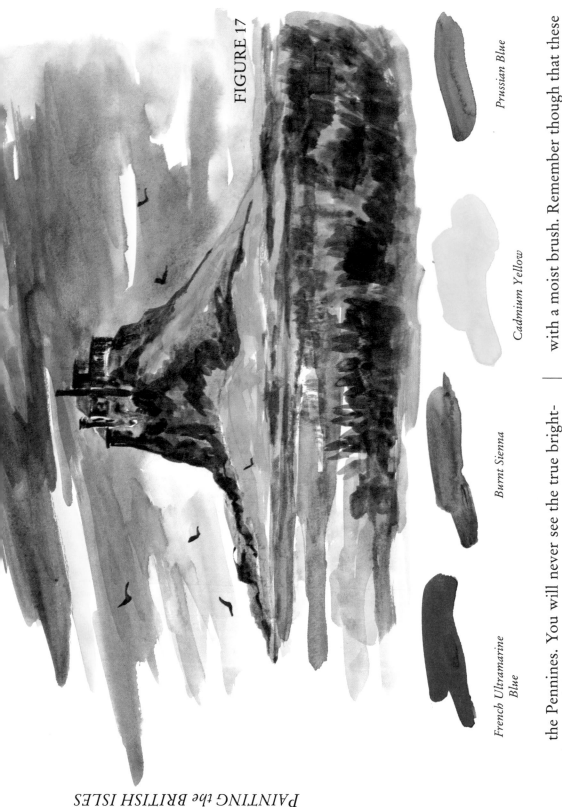

FIGURE 17

French Ultramarine Blue

Burnt Sienna

Cadmium Yellow

Prussian Blue

the Pennines. You will never see the true brightness of the yellow in it until it rains, and then it seems to illuminate the whole landscape. Up here in Northumbria, the glow still lingered because the sea had just dispersed, and I was truly in my element as I tried to capture the algae on the rock and poles with a mixture of Prussian Blue and Lemon Yellow, pulling out the lights of the poles

with a moist brush. Remember though that these are details that are to be added just as you are about to sign your name. We all want to put the windows of the castle in first, but these were put in after I had used the moist brush on the poles.

My painting is a homage to the early pilgrims who discovered and opened up this sanctuary – Lindisfarne, a true artist's paradise.

FIGURE 18

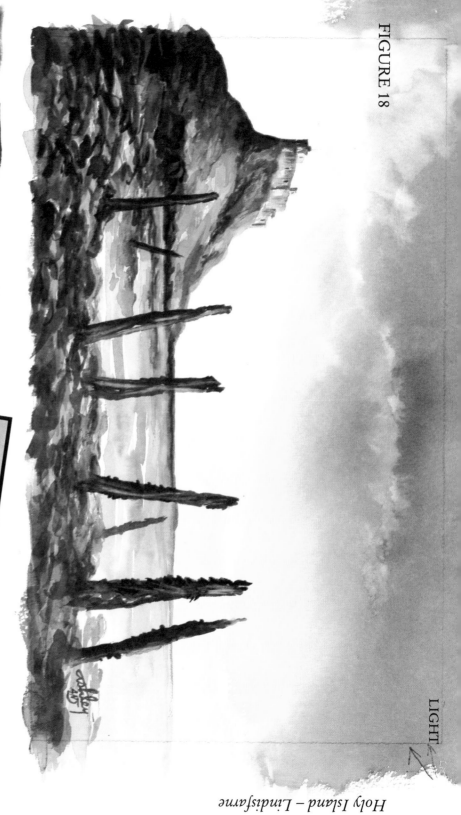

LIGHT

Holy Island – Lindisfarne

French
Ultramarine
Blue

Prussian Blue

Burnt Sienna

Crimson
Alizarin

Lemon Yellow

▶ The Holy Island is a real hidden
gem. Here we see the view of the
Pilgrim's Way and castle (right)
which I chose for my final painting
(above).

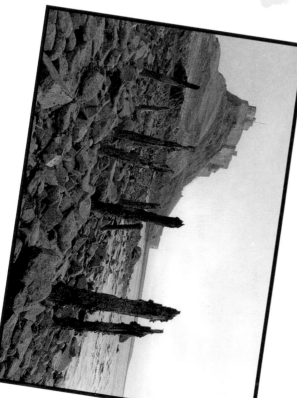

WRYNOSE PASS

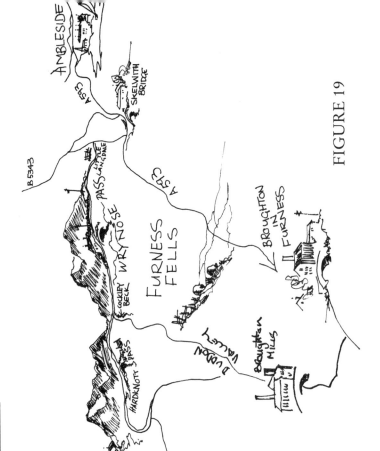

FIGURE 19

I could not wait to reach my next port of call, the country of Wordsworth, the Lake District. Wrynose Pass was my destination. Before embarking on my journey I had searched my map in frustration for this pass, which seemingly had disappeared from the face of the earth, convinced that it was spelt like the animal, the rhino. The correct spelling apparently originated from the Romans and the pass takes its name from the twelfth-century records, of Wrayene meaning 'path of the stallion'. When you visit Wrynose Pass you will thoroughly appreciate this meaning!

L eaving picturesque Ambleside with its lakeland stone houses and sailing boats bobbing like coloured corks in the water, I began my journey on the A593 making towards Skelwith Bridge (*Figure 19*). I then picked up the signs for Little Langdale; here the road was beginning to climb, twist and turn, becoming gradually narrower. This area is no place for impatient 'townies'; this is a place of tranquillity and beauty and must be treated with the respect that it deserves. As I wound along these roads, following the line of traffic before me, I felt as though I had hooked on to a caterpillar as I crawled along the lanes. One advantage of the snail's pace at which you will

travel in the Lakes, is that you can actually appreciate and enjoy the beauty of the landscape around you. I was indeed stimulated by the scenery, and began to be grateful to the Romans – if it had not been for their magnificent engineering feats which entailed working in harmony with nature to plot the road through the pass, I would have been unable to paint the view.

I could not drive fast anyway as, at every turn, little gems of valleys and becks appeared before

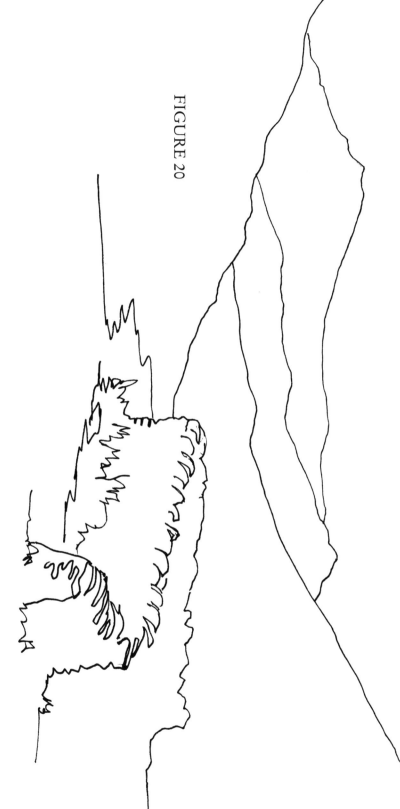

FIGURE 20

my eyes. I could see to my right a moorland wall behind which the mountains surged like waves, creating an effect that I can only compare to that of frozen seas. They formed a perfect recession in the composition of *Figure 20.* I did the drawing very quickly, then jumped back into my car and pulled back on to the road as it would have been inconsiderate to other drivers to have parked at the angle that I had for too long on this busy and narrow mountain pass.

Driving on a few miles, I came upon a lovely dry stone wall with a broken gate, the path lead-

ing up into the mountains. I had to get this down on paper, *Figure 21.* As you can see, I am attract-ed to the skill of bygone craftsmen who built their standing sculptures, these moorland walls, that have become signatures of immortality on these windswept moors.

The light was very soft and coming into the scene from the right-hand side, picking out the stones. With a little imagination, the wall resem-bled a choker of pearls, shining across the land-scape. The fells rolling before my eye with their velvet warm tints of muted green grass looked like

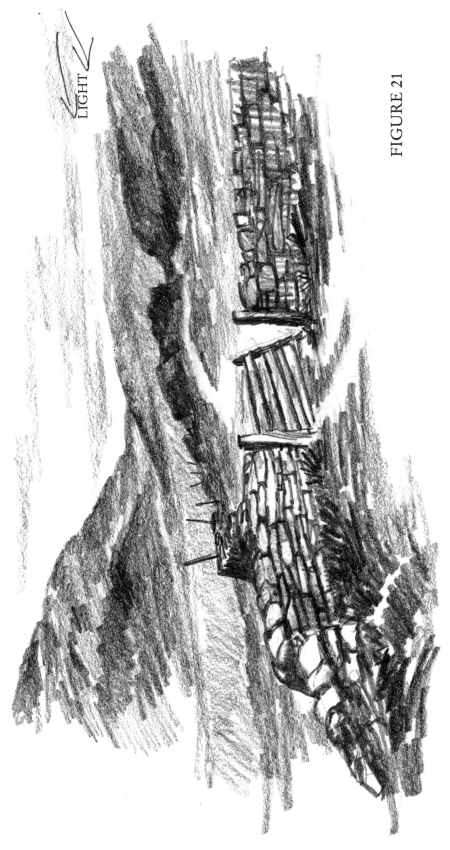

LIGHT

FIGURE 21

a herd of mammals asleep. I tried to capture that texture with my 4B pencil. Shutting the gate, I journeyed on to Wrynose Pass.

Figures 22 and 23 do not run in the sequence of my travels that day. I did these sketches, one with the 4B pencil and the other with ink, after capturing Wrynose Pass in watercolour. The drawings were done while I was travelling down the Duddon Valley. It was at a junction that I stopped to capture this wholly English picturesque postcard view – *Figure 22*. Feeling like an intruder, I sat almost guiltily on a rock to draw this idyllic mountain scene, feeling as though I were invading the privacy of the occupants. I executed this view quickly with my 4B pencil and got on my way.

With *Figure 23* I thought that the mountains in the distance looked quite majestic, like some Egyptian pharaoh's pyramids. The contrast between the flat plain of the valley and the mountains piercing the sky, was so great that I had to capture it.

Wrynose Pass is one of the few roads in the country on which a driver can feel like a mountaineer without having to put boots on. You can

truly appreciate the sheer exhilaration that a mountaineer must feel having climbed to such spectacular heights, breathing in the ice-cold air. The journey alone to Wrynose Pass is well worth the effort, even if you never actually take out your paints.

▼ The mountain bridge at Wrynose Pass (right), a view which I had long wanted to capture in watercolour. Note the light coming from the centre of the sky.

FIGURE 22

Driving up Wrynose took me back to my youth. In those days I would have thought nothing of scaling these peaks and ridges like a mountain goat. I am certainly grateful for the technology of the twentieth century which allows one to motor to these heights in relative comfort without a rucksack on your back. I still ridge walk now, but not with the same flexibility that I had as a youth. How true the words of Bernard Shaw: 'what a pity youth is wasted on the young'.

Making the most of being up there in such isolated and exposed conditions, and totally refreshed, but praying that I would not break down, I parked the car in a small car park. Taking my watercolours with me, I began to walk. I had

seen this mountain bridge on many occasions and always said that I would paint it one day. Well, this was to be the day. I sat down at the bottom of a wall some 200 yards (220 metres) away from my car. As the time went on, I got colder and colder, and kept remembering that the car had a warm heater in it. I tried in vain to make myself as comfortable as possible, taking shelter from the ice-cold edge of the raw wind which was already beginning to penetrate my bones. Crouching like a moorland sheep, with the wall behind me, protecting me from the elements, I did a working study in watercolour of the bridge and Wrynose Pass, *Figure 24*. Observing the light I realized that it was coming from the centre of the sky. I painted

FIGURE 23

this watercolour directly without mapping it out first in pencil. I felt that to paint direct would give me the confidence that I required to tackle a final painting of this subject. The colours that I used in this figure were Lemon Yellow, Ultramarine Blue, Prussian Blue, Crimson Alizarin, Burnt Sienna and Raw Sienna.

It is easier to show the viewer that a painting was conceived from a great height if the mountains and ridges that you are capturing have peaks to them. The peaks will recede in perspective, in other words, they will seem to be larger in the foreground and smaller as they go into the background. Your painting will automatically be given the recession and depth that you require.

Living where I do, in the heart of the Yorkshire Pennines, where there are plateaux rather than peaks, it is more difficult to give the viewer the feeling that the painting was created high up where the summits are flat. If you are not careful, you can create a painting that looks as though it was conceived from the vale of York instead of giving the feeling of being on a table-top with large and vast skies all around. Painting in a mountainous area, such as the Lake District, Scotland or Wales, it is much easier to capture the feeling of height from where one is painting because of the glacial peaks.

The sky on this day intrigued me with its white low clouds on a worn backcloth. The white clouds seemed to traverse from one mountain peak to another, giving you a feeling of travelling under a bridge. The light was coming from the centre of the sky as in *Figure 24*. In *Figure 25* I

wanted to capture the purple of the mountains in the distance, which reminded me of a line in Tennyson's poem, 'The Miller's Daughter': 'the purple in the distance dies.' The words of this poem were a great help to me for they kept reminding me to paint the vista softer than it really was. Students must be aware that, when out painting a scene, it is important not only to scale down the size to get it into the picture, but also the colour and tone of the view.

After painting the sky, I put in the soft, warm washes of the distant hills. I shaped the bridge, putting in the darks first and then the dark side of the beck and its banks. I then painted in the left-hand side shaded mountain with Prussian Blue, a little bit of Ultramarine Blue and a pinhead of Raw Sienna. Now my painting was beginning to take shape.

The middle distance fells were created with a mixture of Ultramarine Blue and Prussian Blue and a touch of Raw Sienna. This was carried out on all the other middle distance and foreground moorland grasses.

The colour of the road was formed by using the same colour mix as the shaded sides of the wall, but this time a lot more water was used in this mix, to make it into just a tint.

You will notice in this painting that there is not much detail in it. By detail, I mean that I have not used a brush smaller than a pointed number 8 sable to create the effects in my painting. This picture was executed with a large inch wash brush of squirrel hair and a number 8 sable. Having practised with *Figure 24*, I found that I had gained the

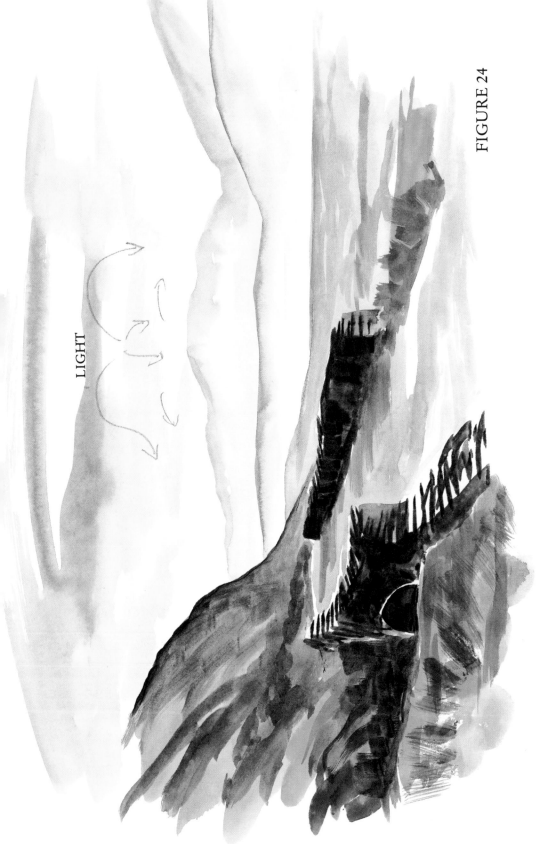

LIGHT

FIGURE 24

confidence to paint with just two large brushes.

The cloud formation was created by first wetting my wash brush with clear water and pulling it through two fingers then using the moist brush to roll along the wet sky on the paper, pulling out the colour and forming white clouds. Only by using natural hair brushes and good quality rag paper will you achieve this effect.

You do not need to paint to appreciate the beauty of the views: you can have an artistic feeling without having to pick up a pencil or a brush. But it is a bonus if you can then go on and interpret a view on watercolour paper.

My day out in the Lakes was an exhilarating experience, but yet again I found myself practising; this time, exercises with my brushes. I found

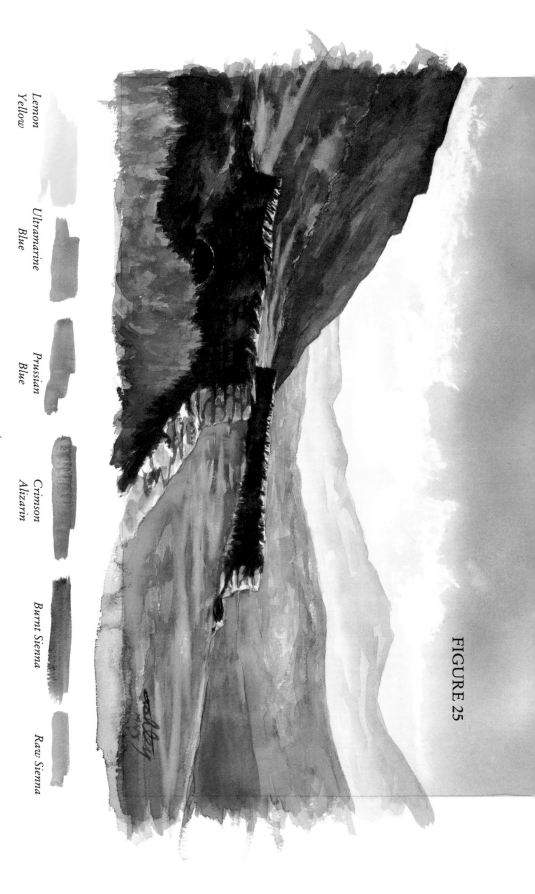

FIGURE 25

that the wash brush, a completely different shape to all the other brushes, requires a different technique as the hair is much softer. You must be aware of this when using it, and practise long and hard with it. You will soon be more than satisfied with the results you will achieve.

I found that the number 8 sable was firmer and easier to use as a drawing brush. I discovered that if I knocked the bristles to one side it gave me a pointed chisel edge which was ideal for drawing out with. This brush can create many effects. It is essential that you discover the capabilities of your brushes and find out what extremes you can push them to. What better place could you possibly want to get to grips with such practice than in the open air of the Lake District.

Lemon Yellow

Ultramarine Blue

Prussian Blue

Crimson Alizarin

Burnt Sienna

Raw Sienna

SNOWDONIA

As a teenager and into my late thirties, I went rock-climbing and mountaineering. I still enjoy ridge walking now, but it was rock climbing that used to be my passion and absorb a lot of my leisure time. Wales, and in particular the Snowdonia National Park (*Gorffwysfa* is the Welsh name for this area), with its sharp rock faces, is perfect for such hobbies, and I have grown to love this part of Wales more and more.

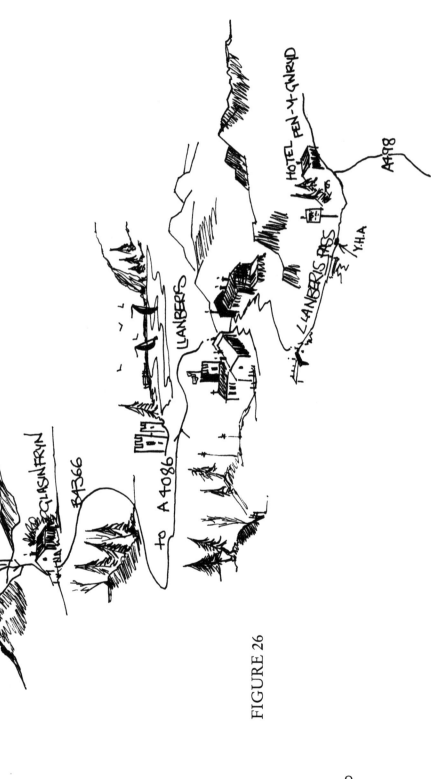

FIGURE 26

I first visited Wales as a young boy of eleven with my parents, staying in Rhyll and seeking out Randolph Turpin, the famous boxer's training headquarters. The highlight of the holiday for me though, was driving through the Llanberis Pass. At that time, I thought it would be the last time I ever saw it, but the mountains of Wales called me back, and with a party of boys at the age of sixteen, we camped out in Nant Peris, aiming to climb the majestic and challenging Snowdon. I remember that it rained all week and that the mist shrouded everything. However, we did climb to the top, and the very day we achieved this, the clouds parted as though Moses had given the command for us to be able to view what was such a beautiful landscape.

Leaving the past behind, I set off from Bangor retracing the steps of my youth, this time by car, not train (*Figure* 26). I followed the signs for Llanberis through Glasinfryn and got on to the A4086 to Llanberis which is clearly signposted. The final part of the journey was to the Pen-Y-Gwryd Hotel, the headquarters of the Snowdonia Mountain Rescue. The weather forecast had predicted snow, and I was eager to capture the region with its snowcapped mountains.

I arrived in Snowdonia at 8am on a late November morning, and I was to experience yet again what I call 'moorland grit' – the very light rain that pierces your bones, puts a sheen on rooftop slates and glosses the road.

There were reflections of light jumping out from every corner. I had to work fast to capture this moment of bouncing light; it was as though

nature was playing her own game of pinball. I got out my cartridge paper sketch book and drew the scene in with my drawing pen *Figure* 27, rapidly tinting the drawing with a Burnt Umber wash.

Journeying on, I came to Nant Peris. This was the very village that we lads had camped at all those years ago. The ground then had seemed to us like a wet sponge, Lord alone knows how we did not end up with pneumonia. I think it could have been due to the large amount of alcohol that we consumed through the night.

I took out my sketch pad and drew the scene which greeted me with my 4B pencil *Figure* 28. It was like looking at a scene through a lightly condensed glass window, and I was like a child using my finger to do a drawing on the glass. Drawing with chalk on a slate board would be more appropriate for this area with its plateaux of slate which remind me of the rice paddy fields of my childhood. As I viewed this town on this wet misty November morning, I realized that yet again the weathermen were wrong and I was not going to be capturing the snowcapped mountains of Snowdonia. I had no enthusiasm to journey on any further. Making the effort to pull myself together, and using an old saying of mine that 'it is better to be alive on a rainy day, than dead on a sunny one' I went on through the mountain pass.

I came across a lovely dry stone bridge that traversed a fast-flowing stream. It showed the pure craftsmanship of the dry stone waller, which in this case was second to none. As the rain had penetrated the stone, it reflected like a mirror the source of light that day. As I stood there I was

FIGURE 27

FIGURE 28

amazed to see the sun slowly beginning to pierce through the clouds and it was as though a curtain was drawing back and allowing me to see the view without any rain or mist. All of a sudden it was very cold, but at least now it was crisp and dry. With a spurt of enthusiasm, I got out my cartridge paper and started to draw the scene in front of me *Figure 29.*

There was a mountain ash which seemed to command my composition. I was above the tree line, and yet this solitary tree had grown there against the odds, probably originating from a seed dropped by a passing bird. To my mind it deserved a place in my picture as it had indeed challenged the tempest of the landscape.

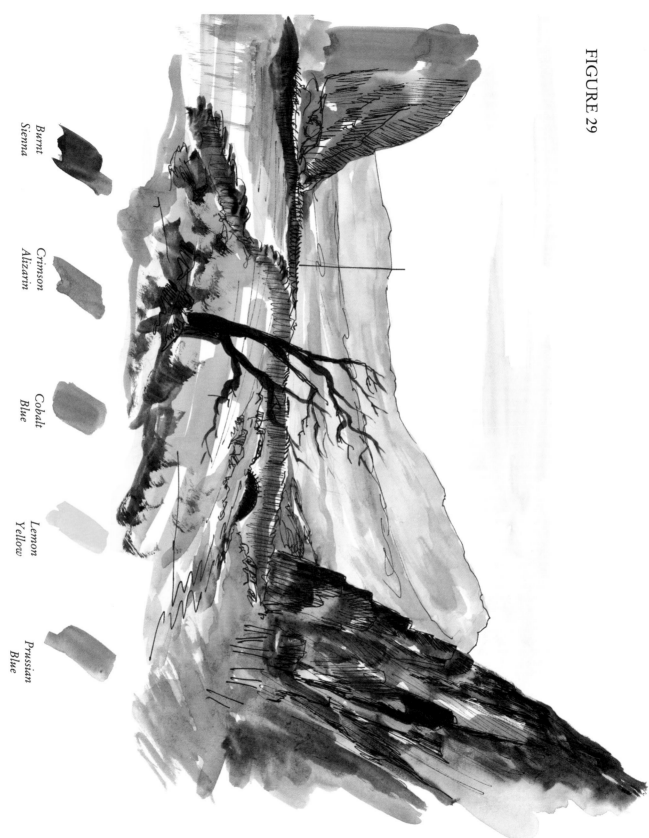

FIGURE 29

Burnt
Sienna

Crimson
Alizarin

Cobalt
Blue

Lemon
Yellow

Prussian
Blue

43

You can see how the prevailing wind had helped shape the tree as there are no branches on its left-hand side. I thought that it would be a great help with the composition as it would guide the eye towards the bridge and once hitting the bridge, the rock face on my right would guide the eye up the valley. The formation of the rocks gave me the feeling that some giant had been throwing them like arrows: the way they seemed to jut out vertically from the ground reminded me of spearheads.

The colours I used to capture this scene are self-explanatory. You may note that I have used red in the middle distance, but I am allowed to do so in this case as it is Crimson Alizarin which is a cold red as it has blue in it. Normally I use reds in the foreground and blues in the middle distance. A more advanced rule of thumb would be to use cool colours in the distance and warm colours in the foreground. This is the perfect example of why you really need to grasp the art of colour perspective in order to thoroughly enjoy painting. There is no fun in breaking the rules if you do not know what the rules are in the first place!

Passing the YHA at the top of the pass, the Pen-Y-Gwryd Hotel at the bottom was a welcome sight. Its lonely location reminded me of being out on the high seas with the hotel as a little cork bobbing in the swell. This sight I captured with my drawing pen in *Figure 30*. The mist began to rise and open up the scene, enabling me to capture light and dark tones in my drawing.

Walking about a mile (1.6km) into the pass I saw a landscape that was breathtaking. Breathing the air was as good as drinking a good bottle of

champagne, making me feel quite intoxicated – Wales seems to have this effect on me, recalling my Nant Peris experience at the age of sixteen.

The dramatic landscape before me with its dark green shadowed mountains and rich burnt sienna bracken, all the colours of the earth, was truly a spectacular sight. However, I had come to Snowdonia to paint snow and there was not any, so, should I leave and come back another time? An artist is blessed with the gift of imagination. I really felt that I could, if I thought long and hard about it, feel and imagine snow to be around me. My decision was made, I would stay.

I got out my pen and drew as simply as possible the composition which lay ahead of me, *Figure 31*. I did this to ensure that in my final painting the viewer's eye would be led into the painting in the same direction as the arrows in the workout. I was going to change this wet November scene into a cold, crisp, snow-clad day.

Many students panic when attempting to paint snow in what I call the English school of watercolour painting. This technique means not using white pigment for your light; instead using the white of your paper.

Your approach should be a monochromatic technique, painting in from the horizon to the foreground, painting in dark areas first. You should put in the darks first to achieve my style of painting, although many books advise you to put in the lights first. This is very misleading as it is difficult to put in whites when the paper is already white – your painting would take on no shape at all. The simple rule is that your darks go in first, then the

lights automatically take care of themselves.

I started to paint, working carefully from the background to the foreground. You will see from the photograph of the location that I have used the same cloud formation as on the day, so I have not totally changed the view in front of me.

The majority of students in their early stages of painting, when asked what colour snow is, will answer straight away that it is white. Yes it is, but white reflects light and colour, so one must ensure that the colour of the sky on the day is reflected in the snow.

My snow was made up of the sky colour, this

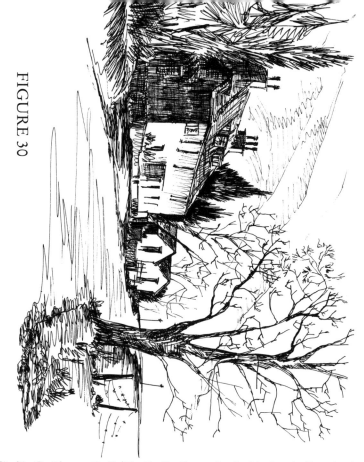

FIGURE 30

being equal quantities of Prussian Blue, Ultramarine Blue and a pinhead of Burnt Sienna and Crimson Alizarin. When mixing, if you find that you are not achieving the colour that you desire, keep adding the colour as pinheads into your mixture. The golden rule is not to mix in large quantities but work very sparingly, treating your colour like gold dust. Do not overmix.

Painting snow is good practice for painting tonal values. It also helps you in the art of recession. I have tried to capture the mist in the far distant mountains. This was achieved by simply painting in the mountain ridge and pulling the colour down with some water, making it so weak that it married into the white of the paper.

In a snow scene it is important to remember that it is not what you put in, but what you leave out that makes it an absorbing painting. Try and make the composition as simple as possible. I always think of Oscar Wilde and his statement that 'too much detail can be vulgar' when I am painting. To paint a simple painting, is more difficult, as you have no 'frilly bits' to hide your mistakes, but it is a lot more challenging and the end result is more satisfying – try it for yourself.

I used the fences and the stile in this composition to lead the eye into the picture and down on the left-hand side into the gully and frozen beck. This subconsciously takes you into the picture, as was my desire with the arrows in *Figure 31*.

The tufts of grass, penetrating through the snow like feathers in a native American headdress, encourage the impression of a crisp, snow-blanketed day. To achieve this effect I used a dry

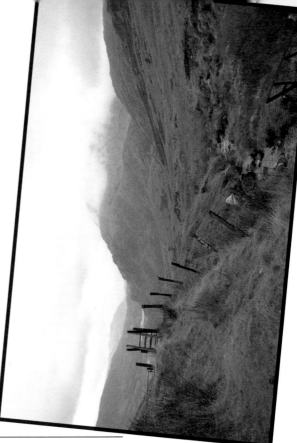

What I have done is to use my experience as an artist who has been out and captured snow many, many times, transferring these experiences on to paper to give the viewer the feeling and impression of snow even though the picture was painted on a wet November day. I sincerely believe that you can capture memories and experiences in your mind, and store them away to uncork at a later date. Even my favourite artist and mentor, Turner, did this. He commissioned a sea captain to take him out to sea strapped to the prow of a ship in a storm. Whilst at sea he never painted, but, back on *terra firma* he uncorked the now full bottle of his mind and painted the magnificent, moving and dramatic 'Storm at Sea'.

I have always had great admiration and respect for Turner, and use him as a yardstick. With this, alongside common sense, one cannot go far wrong as an artist. I hope that you enjoy your day in Snowdonia as much as I did.

FIGURE 31

brush for the clumps of grass. All these details were done at the end of my painting (*Figure 32*).

Some people will say that I could have done this scene with the snow while sitting by the side of a warm fire at home. However, I believe that you need to be out in the open air to capture a scene. If I had not been in Wales on that day, I would have been unable to paint the true shape and atmosphere that the mountains radiated. Atmosphere is the one thing you do not get from sitting in a wall-to-wall carpeted room, trying to capture an outdoor scene.

This was the view that greeted me in Snowdonia (right). In my finished painting (opposite), simplicity is the key to the snow scene I created.

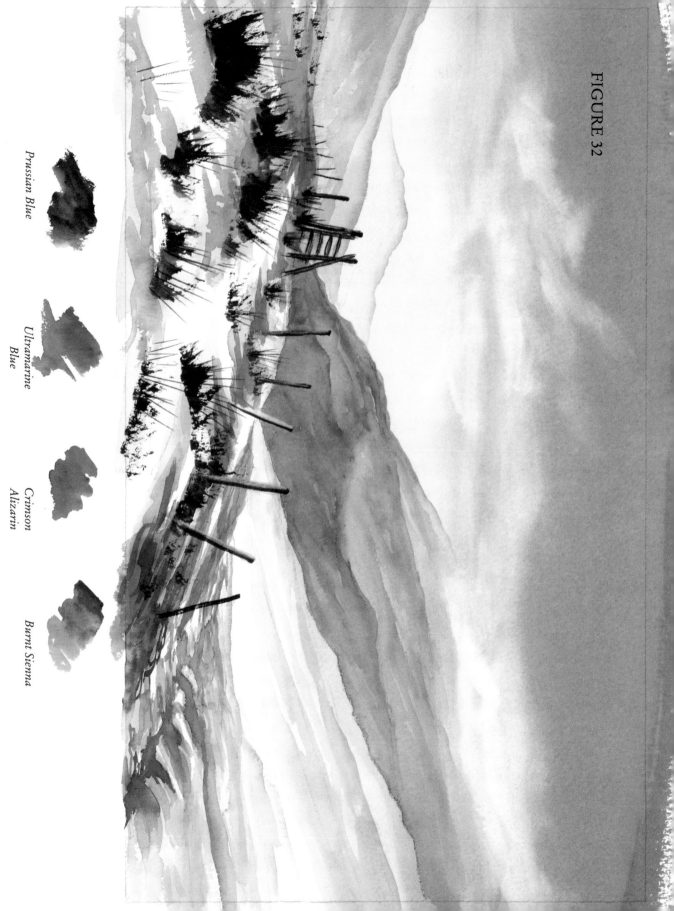

FIGURE 32

Prussian Blue

Ultramarine Blue

Crimson Alizarin

Burnt Sienna

47

ROBIN HOOD'S BAY

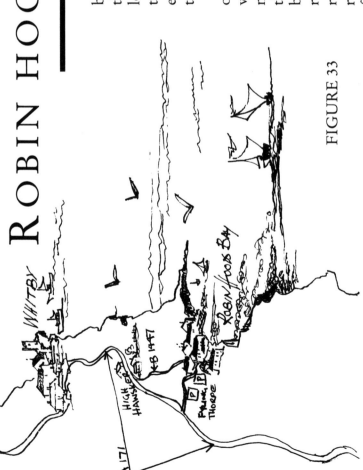

FIGURE 33

Nestling at the bottom of the North Yorkshire Moors, and clinging to the steep slopes of the east coast between Scarborough and Whitby, lies one of my favourite coastal coves, Robin Hood's Bay. (Despite the name, it has no known relationship with the famous Robin Hood of Sherwood Forest.)

I reached my destination by travelling from Whitby on the A171, signposted to Scarborough. After 3 miles (5km), I turned left, following the signpost to Robin Hood's Bay (*see my map, figure 33*). On arrival, I found that it was

best to leave my car in the car park at the top of the hill, which also has conveniently situated toilets, and walk the quarter of a mile down the hill to the bay. Here you will find many câfés and taverns where you can stop and rest and have a bite to eat – the fresh fish is highly recommended!

While walking down the hill, to my left I observed what is already a frequently-painted view of the town and I captured it quickly with my felt pen (*Figure 34*). Perhaps one reason why this is one of the more popular depictions of the bay is that many artists may lack the stamina required to reach the bottom of the bay! Another reason for its popularity is the fact that it is a ready-made composition, because as you will find, nature helps you to cut out the foreground: the foreground disappears into the ravine which separates us from the middle distance, the middle distance becomes the foreground. I have done the same thing in my sketch, thereby allowing you to go for the middle distance and far distance of the composition, which simplifies the subject.

If, on getting out of the car, you feel that you cannot venture into the bay, the cluster of houses clinging to the windswept hillside, with their red pantile roofs and the bay in the far distance, makes this a challenging and picturesque scene to capture.

Going further down the hill I discovered, as you will, the many nooks and crannies which are

FIGURE 34

so characteristic of this former smugglers' cove. Walking down you will really start to feel the spirit of this fishing village, and to wonder what tales these stones could tell if only they could talk. The houses are very intimately clustered together; in the nineteenth century, when the Customs men came to look for smuggled goods, they found they were up against a hard task, for it is said that 'a bale of silk could pass from the bottom of the village to the top without seeing daylight', because the houses are so close together.

I captured one such cluster of houses in my sketchbook (*Figure 35*), executing it rapidly as I was becoming enthused and excited by the atmosphere of the place. I was now beginning to smell and taste the salty sea air and I could not wait to see what was around the next corner. I hoped the vista would make the hairs on the backs of my

hands stand rigid: if it did, I would know that this was the scene for me to paint.

Descending into the harbour, leaving behind the cluster of fishing cottages that was just beginning to make me feel a little claustrophobic, I saw the sea, which gave me a breath of fresh air. I then came upon the Bay Hotel, with its fishing cobbles in the yard. This I roughly sketched with an ink pen, feeling that I might become emotionally moved to create a painting (*Figure 36*). I was holding myself back from getting too excited. I decided to walk down the landing ramp and on to the rocky shore, to see if I could discover another potential sight to capture. I looked back over the path that I had taken, and wow! – the picture hit me like a bolt from the blue.

I did not need to ask myself whether the hairs on the backs of my hands were beginning to stand

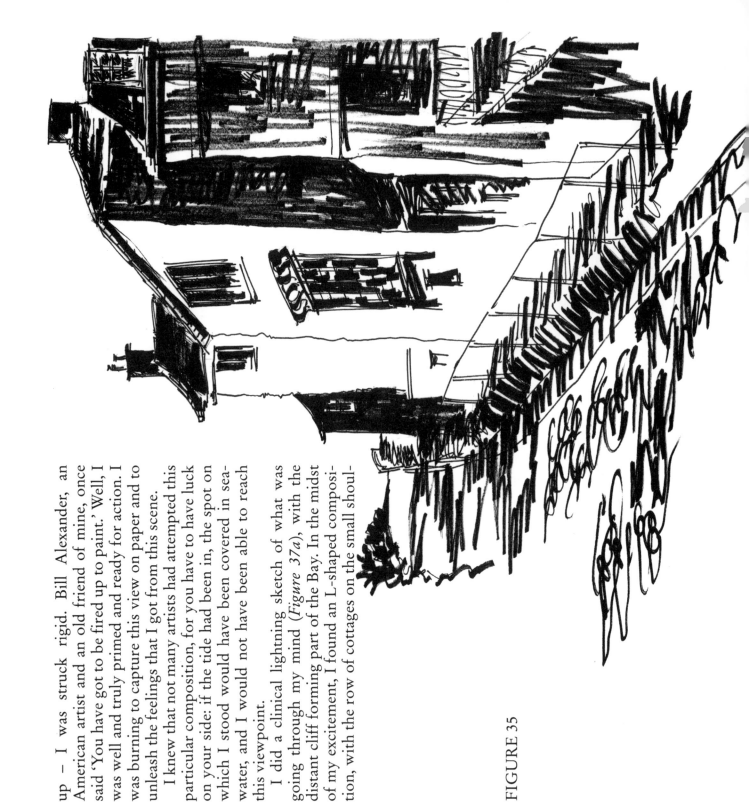

up – I was struck rigid. Bill Alexander, an American artist and an old friend of mine, once said 'You have got to be fired up to paint.' Well, I was well and truly primed and ready for action. I was burning to capture this view on paper and to unleash the feelings that I got from this scene.

I knew that not many artists had attempted this particular composition, for you have to have luck on your side: if the tide had been in, the spot on which I stood would have been covered in seawater, and I would not have been able to reach this viewpoint.

I did a clinical lightning sketch of what was going through my mind (*Figure 37a*), with the distant cliff forming part of the Bay. In the midst of my excitement, I found an L-shaped composition, with the row of cottages on the small shoul-

FIGURE 35

der of the cliff whose gable end was facing the sea. You will find that this is characteristic of the buildings in most fishing villages, as the gable end is positioned to receive the pounding of the wind and rain, thus keeping the houses warmer than if the windows and doors faced the sea.

To emphasize the L-shaped composition, I have drawn a large L over the top of it in felt pen. The L, beginning on the left, frames the distant view of the cliff and the open sea, which is where I want eventually to allow your eyes to wander: this is the escape point of the painting, and I have marked it with arrows.

The reason that I chose this composition was two-fold: the cottages clinging to the hillside in my L-shape provide my painting with a lot of detail, while the sea that they look out on has no detail, this part being a challenge. I find, as you will, that it is easy to paint something that is man-made, such as windows and chimneys which have plenty of detail, while it is hard to paint something relatively featureless, such as the open sea. In this composition I was able to marry the two extremes together, which I found very challenging.

To give the sea some movement, and make it lie flat rather than sticking up like a brick wall, I used nature's light to give me tonal value. The foreground of the sea has lights and darks in sharp contrasts, but as the sea disappears towards the horizon these lights and darks become weaker. This makes the sea in a painting 'lie down', and gives it depth. It also prevents the sea looking as if it has been stuck on as an afterthought.

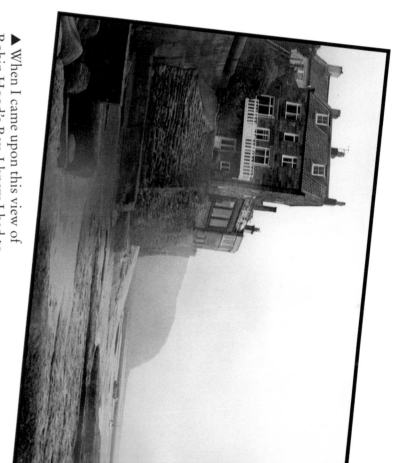

▲ When I came upon this view of Robin Hood's Bay, I knew I had to paint it. The challenge was to marry together the detailed houses with the relatively featureless sea.

By this time I felt that I was really experiencing all the emotions of the way of life of the fishermen who lived here, striving against the elements to get their catch and earn their living. When painting on location and getting to this point, where I have found the right sight and composition for me and I have well and truly begun to soak up and feel the atmosphere created around me, I always try to see the view in terms of tonal values. Choosing just one colour to make a sketch with is a good test of how much atmosphere you really

FIGURE 36

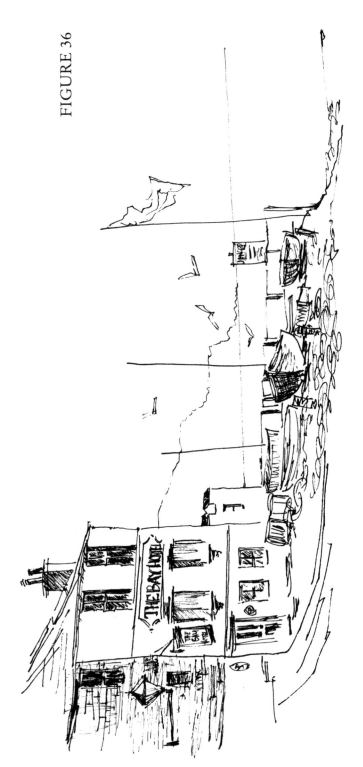

The French Ultramarine Blue is a warm blue, having got some red in it, and therefore adds some warmth to the painting. I find the Prussian Blue a cold blue, so I used it in the cold, dark corners of this painting. Burnt Sienna, on the other hand, is a very rich pantile red, and is ideal for capturing the subdued warmth of the buildings that is so characteristic of Robin Hood's Bay. I used Raw Sienna because it is a warm yellow. By using the two blues together in equal quantities I was able to mix my key colour, the colour of the sky, which I then used in every area of the painting to give it unity (see the Introduction). By using your key colour in this way, your whole painting should look more of a piece, as if you had captured one moment in time.

I began the painting by wetting the sky all over

have taken in, and I knew that if this came out right, I could proceed to create a painting of this stormy, windswept bay. On viewing the results of my monochrome (*Figure 37b*), I realized that I had begun to feel, smell and touch Robin Hood's Bay, and I knew then that the time was right for me to capture in full watercolour this particular moment in time.

Bearing in mind that it was the sun coming through the breaks in the cloud (or windows in the sky, as I like to call them) that was giving me the areas of light in the composition, I used a limited palette of four colours – two blues, a red and a yellow – to achieve this painting (*Figure 37c*). The colours I used were French Ultramarine Blue, Prussian Blue, Burnt Sienna and Raw Sienna.

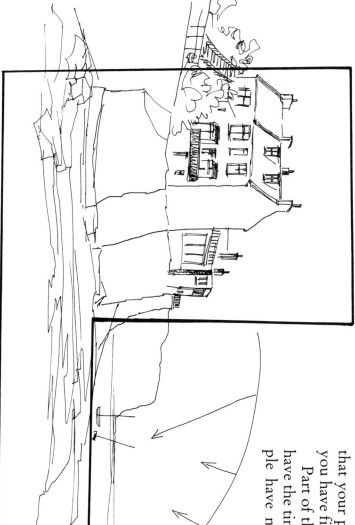

FIGURE 37a

with clear water, using my wash brush. Working from the top of the painting downwards, I then dropped in my key colour, going from its strongest tones behind the houses to its weakest tones out to sea.

Cleaning the wash brush out, I then pulled out the clouds, tilting the clouded sky to convey the feeling of movement and wind that I was experiencing that day. If you paint clouds level with the horizon, you will find that this creates the feeling of a still day, rather than a windy one. By tilting the clouds in the sky, you can give an impression of the wind blowing the clouds and make them appear to be skating across the sky. To give the impression of the shadows of the moving clouds falling on the buildings, I used the sky colour with a pinhead of Burnt Sienna mixed in.

One of the problems that you will encounter when painting the red pantiles of the roofs is that you will instinctively want to paint them in the same vibrant reds as you see them. It always amazes me to find that the student who happily scales down the landscape to get it into the size of their canvas never thinks of scaling down the colour and tone as well. Always remember to tone down everything you see; this will ensure that your painting does not 'shout' at you when you have finished it.

Part of the beauty of being an artist is that you have the time to observe, a luxury that some people have never known. One particular thing I

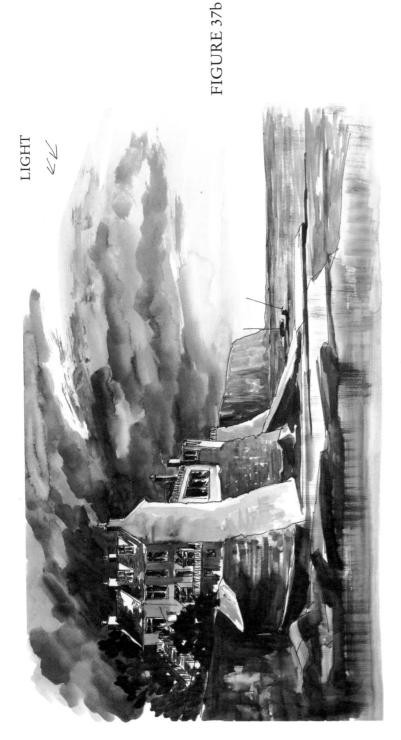

LIGHT

FIGURE 37b

noticed about the red pantiles of the roofs is that they all have on them something called a witch's seat. These ridges, running up to the apex, help to secure the pantiles and to prevent them, not from being blown away, but from being literally sucked off by the force of the wind in a storm!

To create the watery feeling of the pools around the left-hand corner of the painting, I used a dry brush to drag a little of the paint in the pools vertically downwards on to the moist paper below, thereby giving the effect of a watery reflection. Try this technique for yourself, and you will find that the feeling of water in your work is instantly achieved.

My journey to Robin Hood's Bay was an exhilarating experience. I saw many sights on my day there that I felt I could have captured. My sketches, which I see as visual shorthand notes, show just a few of these alternatives. I hope that in this chapter I have been able to emphasize to you the fact that when visiting a location it is essential that you really *look* first. Only once you have had a thorough look around can you bring the next most important sense, your sense of smell, into use. The combination of these two senses is crucial both in picking a location and in then conveying the emotion you feel in your painting for others to appreciate and understand.

French Ultramarine Blue

Prussian Blue

Raw Sienna

Burnt Sienna

FIGURE 37c

Robin Hood's Bay

SHERWOOD FOREST

As you can see from the map (*Figure 38*), I then crossed on to the A616 to Cuckney. At this point of your journey you will start to feel the same excitement as I did when I saw the sheer vastness of the forest, and the tall majestic trees that lie ahead. I followed the road down through Budby through avenues of Lincoln Green, on to the B634. I then followed the signs directing me to the Major Oak and the car parking facilities for the forest.

I had been advised to arrive early in the forest as it is one of Nottinghamshire's largest tourist attractions, and by midday can be thronging with people who, like myself, want to bring alive their childhood images of Robin Hood. I selfishly preferred to have this experience alone, and be able to capture my impressions on watercolour paper without any distractions. I was privileged to be guided around the forest by the countryside ranger Andy Boroff, to places where the public normally are not allowed. I learnt that some areas of the forest border on land owned by the Ministry of Defence, so it would be too dangerous to ramble around. I hasten to add we did not stay too long there either.

Once back in the public area of the forest, I was left alone to discover for myself its full charm and beauty. As I walked across the bracken and down the heavy glades I felt it was an ideal place to see the will o' the wisp. The forest has, as you will

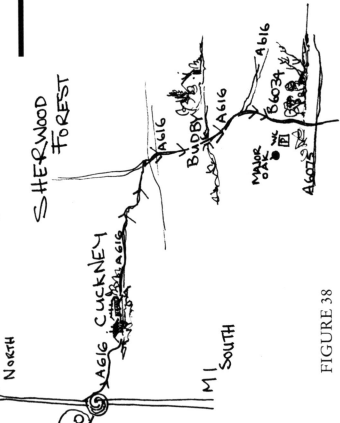

FIGURE 38

One of my childhood heroes was Robin Hood, particularly as played on the silver screen by Errol Flynn. One assumed Robin Hood was the Earl of Huntingdon who legend had it was supposed to have robbed the rich to give to the poor, but recently I was saddened to hear that there were quite a few 'Robin Hoods' around at the time. However, I still carried in my mind my Errol Flynn image of Robin as I approached junction 30 of the M1 and headed towards Sherwood Forest, the home of Robin Hood.

discover for yourself, an enchantment all of its own; you start to imagine that there might really be fairies in the next glade.

I cannot believe that anyone who visits this forest does not feel the spirit of Robin Hood, Maid Marion, Little John, Will Scarlet and the large and portly Friar Tuck lurking around every tree, watching your every move. Talking of trees, these were at the heart of my coming to Sherwood to paint. These old oaks always look full of wisdom as they stand so straight and proud. In painting

these great giants of the past still standing majestically, I was hoping that they would reveal the secrets of the past that they alone kept inside those huge and powerful trunks. When painting a landscape, you have to be at one with your subject, and only when you get close to the subject are you able to transfer the message on to paper.

As an artist, I felt now that I was in an elephant's graveyard as I stood looking up at these giants with their trunks and tusks swinging up into the sky. As a teenager painting trees, I always thought that in winter they looked like hands stretching out from under the ground, praying to the sky. I have always had, and always will have, a vivid imagination!

Sherwood Forest is a network of mazes. The path that I chose to take was on the way towards the Major Oak, which is apparently the jewel in the crown of the forest. I was on my way to see and capture it in watercolour. It is a circular route so that you can attack it from whichever way you choose, and you will always end up at the Major Oak.

All along the route to the Major Oak, stand monumental giants from bygone years, still standing firm and proud. In *Figure 39* you will see that I came across one of the unfortunate ones

FIGURE 39

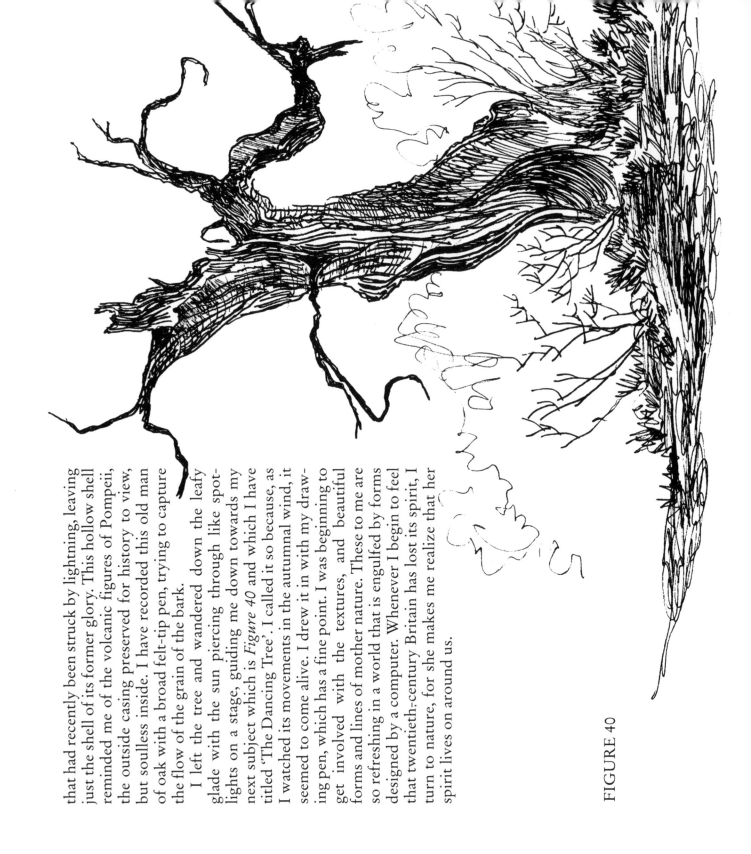

that had recently been struck by lightning, leaving just the shell of its former glory. This hollow shell reminded me of the volcanic figures of Pompeii, the outside casing preserved for history to view, but soulless inside. I have recorded this old man of oak with a broad felt-tip pen, trying to capture the flow of the grain of the bark.

I left the tree and wandered down the leafy glade with the sun piercing through like spotlights on a stage, guiding me down towards my next subject which is *Figure 40* and which I have titled 'The Dancing Tree'. I called it so because, as I watched its movements in the autumnal wind, it seemed to come alive. I drew it in with my drawing pen, which has a fine point. I was beginning to get involved with the textures, and beautiful forms and lines of mother nature. These to me are so refreshing in a world that is engulfed by forms designed by a computer. Whenever I begin to feel that twentieth-century Britain has lost its spirit, I turn to nature, for she makes me realize that her spirit lives on around us.

FIGURE 40

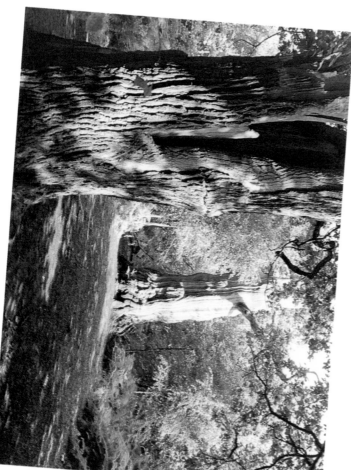

Continuing to tread down the leafy featherbed path, I came across a group of dancers, giving me a deeper feeling that the forest was alive with the spirit of nature, and I was principle guest at the première of a ballet. I had to draw this quickly, to capture the flow of light and shade of the scene before me *Figure 41*. I could not depend on my ink or felt-tip pen for this as they might dry out when I was just getting into the flow of the line. I decided to put my trust in my 4B pencil and putty rubber. This I sharpened with my penknife before beginning so that the lead of the pencil would have that versatile square edge that a sharpened pencil does not have if you use an ordinary sharpener. This form enabled me to capture the full depth and atmosphere of the performance in black and white. Sketching this scene brought to mind the fact that nature has no black outline around her, she is all down to light, shade and tonal value. Remember this when you are out sketching. I hope that, through this sketch, I was able to convey the scene that I was privileged to witness, and when you visit the forest you will also experience the same or similar feelings.

Coming through this dreamland I emerged into bright sunshine and open space, and set my eyes for the first time on the Major Oak standing iso-

lated, like a great person whose days have been numbered, all of its props acting like crutches, attempting to maintain its glory, but failing dismally. To me, it was like walking into a hospital room to see a person you have admired and looked up to for many years because of their strength and principles, kept alive not by their will to live, but by mankind's capacity to take charge with the means of modern day technology, so the body will survive regardless of the fact that the will and soul of the person has been lost.

This great oak has truly lost its soul and fight to live. I felt vulgar and ashamed to be standing looking at this once beautiful and majestic tree. My intention had been to capture this tree on paper, but this idea faded rapidly. I felt guilty in

▶ Just as I was about to give up hope, I came across this beautiful woodland glade. Here you can clearly see the strength of the light piercing the greenery of the forest.

used 140lbs (300g) Saunders Waterford Rough textured paper. You will see from my simple sketch at the top right of the painting, the direction of light at that moment. My aim was to take you, the viewer, into the painting. To do this I decided a double L composition would be the most appropriate, not a U composition. My rough sketch on the left-hand side of the painting confirms my thoughts. The foreground L is formed by the tree trunk on the left with the shadow going across the front forming the base of the letter L, and the trunk of the second tree in the middle distance in the right-hand side of the painting forming the L in reverse, the leg of the L in this case being the trunk, and the foot being made by the light path. This type of layout you will find not only frames the composition but acts as a directional guide to lead your eye deeper into the forest and into the painting.

The fact that you have to think far in advance when composing a painting, makes me believe that watercolour painting and the game of chess are very similar in that you have to think two moves ahead all the time, and know before you start where you want to end up. Only by doing it this way will you create a painting that contains flow and rhythm.

No matter how eager you are to put down in paint what you see and feel, you must always practise the tonal value and construction of a painting first, and be disciplined in these lessons before unleashing your enthusiasm on to paper.

You cannot capture colour without the aid of nature's light; if there was no light in this world

taking part in keeping this tree alive, and I was unable to put my soul into the painting. I ended up capturing it clinically with three colours, Burnt Sienna, Lemon Yellow and Prussian Blue, in *Figure 42*.

I really felt deflated at this point and just wanted to go home. Walking back to my car, kicking up the leaves from under my feet, the image of Errol Flynn began to fade as I realized that, due to yet another piece of twentieth-century marketing of an image we were losing a dream of nature. I was not alone. Many thousands of feet trample each year the same footpath as I had taken, to view the oak, a dying monument, every one of them trying to encapsulate, as I did, the dream of Robin Hood.

I was drawn out of my doldrums by the sight of a rare redstart on the branches of a tree above me. This bird had flown all the way from Africa to be here. On turning around, I saw a green woodpecker working busily on a gnarled tree and heard a jay in the far distance. My heart and soul began to be lifted to a higher level. Instead of looking dismally down at my feet, I found myself lifting up my eyes to find a gorgeous glade unravelled before me.

The reflection of the lights dancing from one tree to another made me feel that Robin Hood had come to my rescue and the sounds of the greenwood were all around me. I was then charged with a feeling that I could not express, taking part in this live performance was a true honour for me.

To capture this marvellous scene, *Figure 43*, I

FIGURE 41

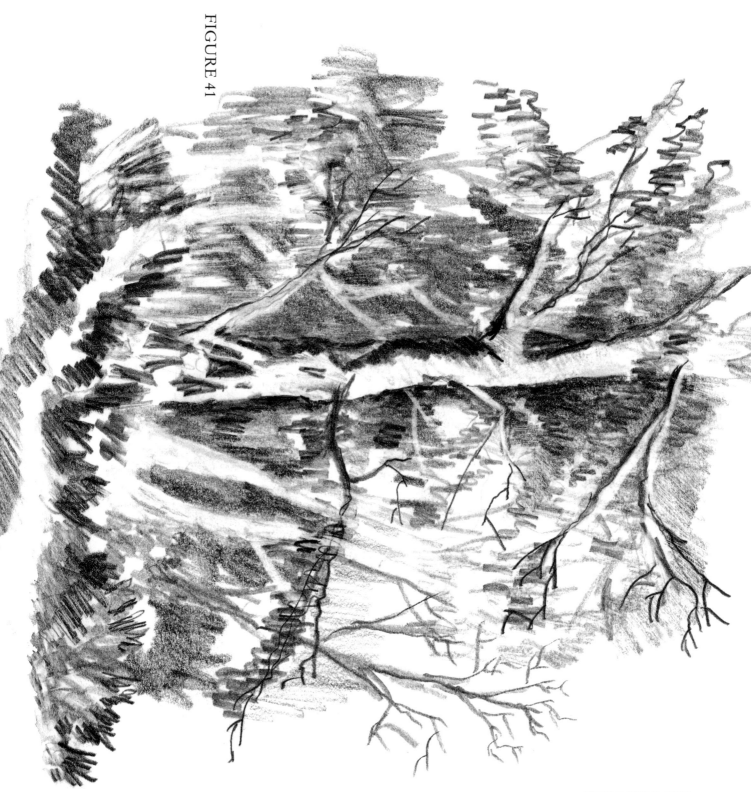

Sherwood Forest

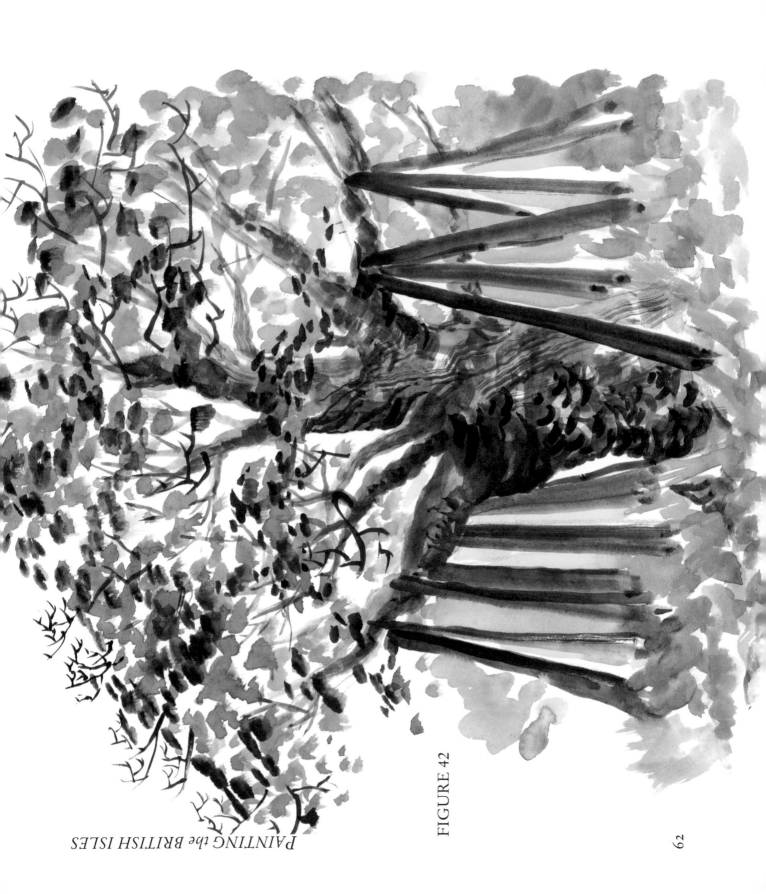

FIGURE 42

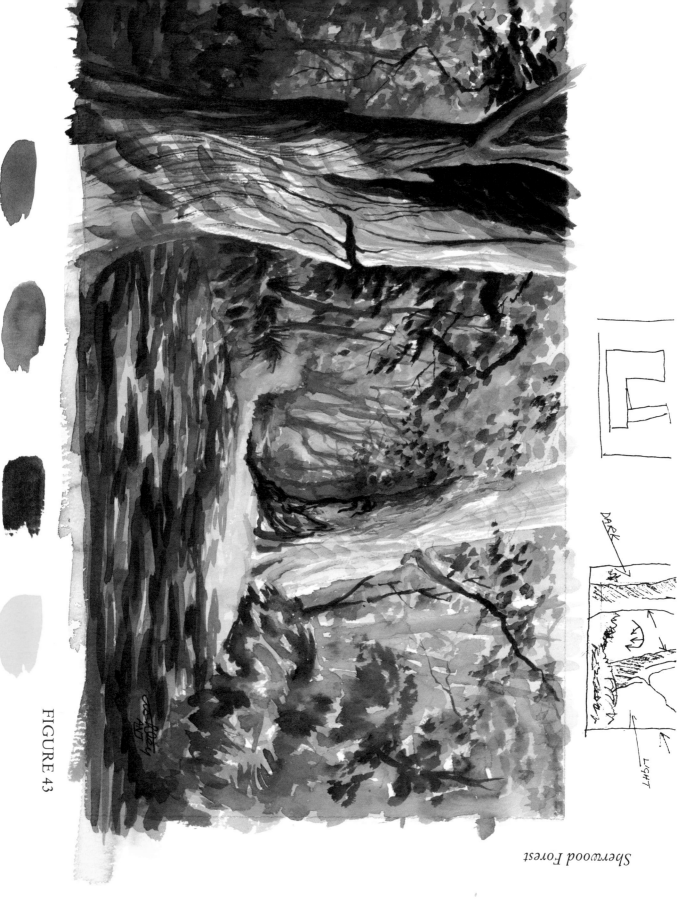

French
Ultramarine Blue

Prussian Blue

Burnt Sienna

Lemon Yellow

FIGURE 43

Sherwood Forest

we would be unable to see colour and shape. This woodland glade was illuminated by the light piercing the trees and reflecting through the lovely green leaves, giving me a true watercolourist's atmosphere.

Capturing the light is the most important feature in a painting, even more so when out on a location such as Sherwood Forest when you want to fully realize on your watercolour paper the shafts of light that pierce the trees before you. On this day it was as though somebody was playing with a high-powered floodlight, setting the stage. To achieve this effect in watercolour is not altogether easy, and takes a lot of practice. You must first find the direction from which the light is coming and note how it is falling in your landscape. When you have done this, you are ready to paint in only the dark side of the trees, that is the areas where the light is not hitting. You will find that this then starts to shape the trunks and branches.

I paint in watercolour in the style of the English School of painting, that is I paint without white pigment in my painting, using the blank paper as a replacement for the lights and whites in my paintings. It is for this reason that I stress, as before, that when capturing light you must always paint in the darks first, so you can see where the lights have to go.

Taking note of how the shafts of light are penetrating through the wooded glade, as I first painted in the dark shaded areas of this wooded glade, I treated the shafts of light that were wanted in my painting as though I had masked over them, and I did not touch these areas until I had worked on all the dark and semi-dark areas first.

Incidentally, I do not use masking fluid: I feel that artists who use this to help them create things, such as shafts of light, create hard and sharp lines that do not appear natural.

The finale in this exercise was to highlight some of the dark shadows in the glade by washing over the area when all was dry with a dirty wash.

I thought that the two tree trunks in the composition looked as though they were having a conversation in which they were including me. So the story in this painting is of the two trees deep in conversation, while the woodland glade around them contains mere observers.

The colours that I used to create this painting are French Ultramarine, Prussian Blue, Burnt Sienna and Lemon Yellow. You will notice also that the foreground and middle distance tree have strong contrasts of light and shade, the darks are dark and the lights are sharp. The distant trees are cold and weak, thus helping to give the painting a two-dimensional feel. This can only be achieved by disciplining yourself in practice. Do not practise the things you can do, practise the things you cannot. That is my golden rule.

I found peace of mind in Sherwood Forest. This is truly a wonderful place to visit with its magical, enchanted atmosphere and wild and beautiful nature. You will definitely find something inspirational to capture on watercolour paper here, and I hope that you enjoy your day out painting in the county of Nottinghamshire as much as I did.

CHEDDAR GORGE

I approached the Cheddar Gorge from ancient England, the city of Bath, built in the time of the Roman Empire. I took the B3135 (*see Figure 44*), observing on my journey how well tended the tall hedges were on this narrow lane. The hedges really were a naturalist's paradise, and it was hard to keep my eyes on the road as I admired the abundance of wild life and plants. My journey across Britain was truly making me appreciate what an impressive landscape we have, and that it is essential that we preserve our heritage for the generations ahead of us.

I had never seen the Cheddar Gorge before, but I had been told on many occasions that it was a sight worth seeing. I had also been informed that in the twelfth century the historian Henry of Huntingdon included the 'Cheddar Hole' in his list of the four wonders of England. Not one to miss out on any experience, curiosity was drawing me towards this limestone cleft which splits the Mendip Hills from top to bottom.

My thoughts were momentarily diverted as my eyes were attracted to two trees ahead of me. They looked like two characterful old men deep in conversation, covered with gnarls and knots formed by the storms over many years. I was fortunate to view these elms in autumn, after they

had shed their leaves, and I could not but help admire the pattern that their twigs and branches made, set against the backdrop of the sky, reaching out like a lace doily towards the high, fluffy clouds. The trees in this part of the country always seem to be fuller and richer than those in the north, even without their leaves.

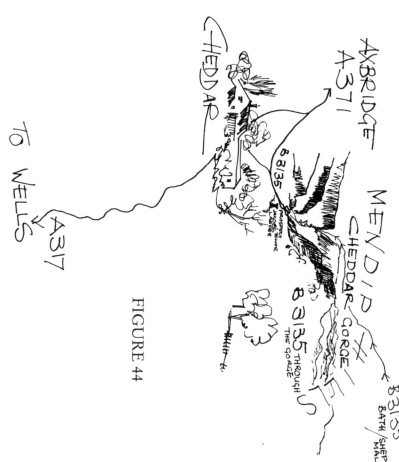

FIGURE 44

I sketched *Figure 45*, this lovely pair of trees, with my trusty companion, my 4B pencil; to me this composition represented the true nature of traditional England, rural, quiet and peaceful.

As I traversed the Mendip Hills my curiosity was turning to excitement as I realized that I had to be very near Cheddar Gorge. I was soon to be rewarded for, all of a sudden, the road seemed to drop. I think it appears more stunning because you seem to be driving on the flat top plains of the Mendip Hills for quite a long time, and then all at once there is a drop in gradient. As I weaved my way down the Gorge towards the small town of Cheddar, I stopped many times in the numerous lay-bys that are provided. Pencil sketch *Figure 46* shows the view from just one of these stops. My desire in this sketch was to capture with pencil the feeling of sheer height that seems to be absorbing you, for the cliffs reach an impressive 500ft (140m) in places above the road. The walls of the gorge were truly towering over me; it is indeed an immense cleft. I thought this composition made a

FIGURE 45

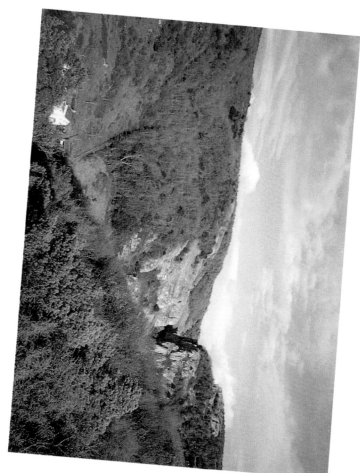

all into scale.

In *Figure 48* you will see that I have done a monochrome sketch using Ultramarine Blue and my drawing pen. I wanted to do a monochrome exercise for several reasons. First, as I looked at the Gorge, I saw it had a haze of blue light around it, and I wanted my final painting to reflect this. Secondly, by practising a monochrome prior to painting, I felt that I would begin to feel at one with the atmosphere and landscape. Thirdly, monochromes are the ideal way to get to grips with depth and tone, and this view without doubt had both these qualities. I did not want to fail it

perfect frame for a lovely light and shade picture of the rest of the gorge – I hope you think so too!

Figure 47 was another lightning sketch that I did of the ravine which was really inspiring me, making me feel that I had plunged into England's smaller and greener version of the Grand Canyon.

I decided that while I was in Cheddar, I would visit the famous Gough and Cox Caves. They are well worth a visit just to see the different limestone formations that nature provides. The silver cascade and helictites, the frozen river, and St Paul's Chamber in Gough's Cave really are wonderful sights, and allow the imagination to run riot. After spending a delightful hour in the caves I headed up the steps known as Jacob's Ladder, built up the side of the Gorge. I was heading for Jacob's Tower as I had been told that from there I would be provided with some magnificent views not only of the Mendip Hills and the Gorge but, as the day was so clear, the Somerset Moors and the Quantock Hills, Exmoor and the Bristol Channel. Tired and exhausted on reaching the top and climbing the tower, my last breath was taken away in sheer exhilaration at the sights before me. I could see for miles. As I looked back down the valley, a little white building attracted my eye and emphasized the size of the gorge and the actual strength of the canyon. This white building put it

▶ My photograph of Cheddar Gorge illustrates the 'flattening' effect of the camera. Always try to paint from real life, not from a photograph.

FIGURE 46

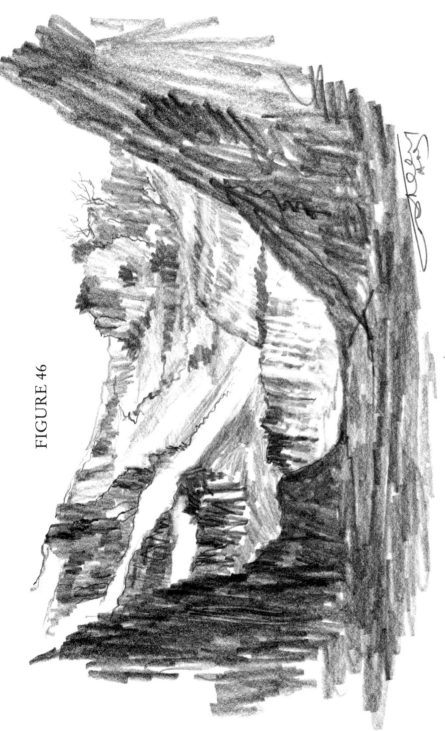

on my final execution. Last but not least, I find that many people can draw beautifully but, when it comes to putting paint to paper, they become frightened. How many times have you heard a student say 'I can draw but I cannot paint'? The monochrome is the transition stage between drawing and painting; it is this part that not only gives you tonal value, but also helps you to get confident with a wet medium, for having to move the wet paint along the paper is an experience all on its own. I advise the artist who is good at

drawing and who wants to progress on to painting to practise monochrome exercises. I have been practising from the age of fifteen, treating them as a musician does his scales. I still cannot practise enough. It was Tony Jacklin, the golfer, who said, 'the more you practise, the luckier you get'. How true are his words.

Viewing the Gorge in my photograph, you will see that it looks like a huge camouflaged hedgehog, the trees and bushes sticking up like porcupine needles in the middle distance and forming

the body, the cliff face forming the face and nose. The photograph that I took emphasizes the difficulty that one has with the limitations of the camera when out painting. I wanted to take a photo of the scene to show you what an impressive sight I was viewing, but somehow the photograph makes the scene look flat and uninteresting, which was far from the truth. The reason that this has occurred is that the camera was focused on the foreground, so had difficulty in coping with the middle distance scenery. Where the eye focuses automatically on any distance or depth, the camera has to change lens to do this. Although I appreciate for some of you it may be hard, you must try to paint out in the open rather than from a photograph back at home. This way instead of copying from a flat, uninteresting photograph which can only make your painting the same, you will create a painting full of life and holding all the distance and depth that you require.

Figure 49 is my final painting of the Gorge and was captured from the top of the tower as I felt that from here I had the best sight of the day.

I drew the subject out on watercolour paper, spending more time on the drawing than usual, and detailing in the clumps of trees and the cliffs. Because of the vast variety of colour in my panorama I used a more extensive palette than normal. The colours included Ultramarine Blue, Prussian Blue, Cadmium Yellow, Cadmium Red, Crimson Alizarin, Burnt Sienna and Raw Sienna.

I then proceeded to wet the sky area in with clean water and mixed a sky colour of Prussian Blue and Ultramarine Blue with a touch of

Cadmium Red, dropping this mix in a band at the top of my painting. I then began to pull the colour across diagonally with my wash brush, creating the feeling of a moving sky.

When the sky area was dry, I tinted it in with a very light wash of Cadmium Yellow and Raw Sienna from the horizon up to the clouds, giving the impression of a warm and sunny day. It was such a sunny autumnal day in fact that for once I could take my time to view the scene and enjoy the painting – not that I do not do that anyway, but whatever anyone says, it is more pleasurable

FIGURE 47

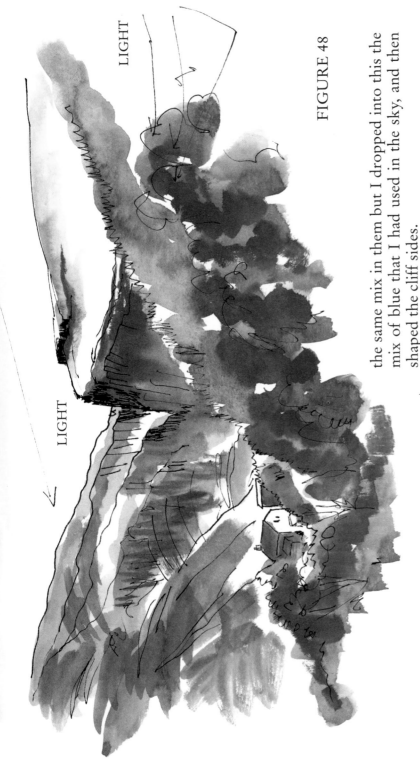

FIGURE 48

the same mix in them but I dropped into this the mix of blue that I had used in the sky, and then shaped the cliff sides.

This painting is a good exercise in painting contours. The majority of beginners, when applying brush strokes on the watercolour paper, always take their strokes from left to right or vice versa, horizontally across the paper, thus creating a very flat painting as this technique does not shape your work. When painting the contours of the land, I always say to my students, 'Go with the flow', and think that, with your brush, you are actually sculpturing the land. This way your painting will never look flat again.

I then painted in the right-hand side of the cliff-top, dropping in the blue sky colour to give a suggestion of the bushes that were clinging to the

when it is warm! The warmth of the day dried my washes more quickly than usual and enabled me to put in the background hills first without fear of an explosion, using the same sky colour mix of Ultramarine Blue.

I then looked at my painting and decided which were the cool areas, placing washes of the blue sky mix in these areas. You will observe from the painting that the direction of light is from the right-hand side. I then mixed colour for the grassy top of the middle distance cliff which can be seen on the left-hand side of the valley. This mix was Cadmium Yellow, Raw Sienna and a touch of Prussian Blue. The cliffs themselves had

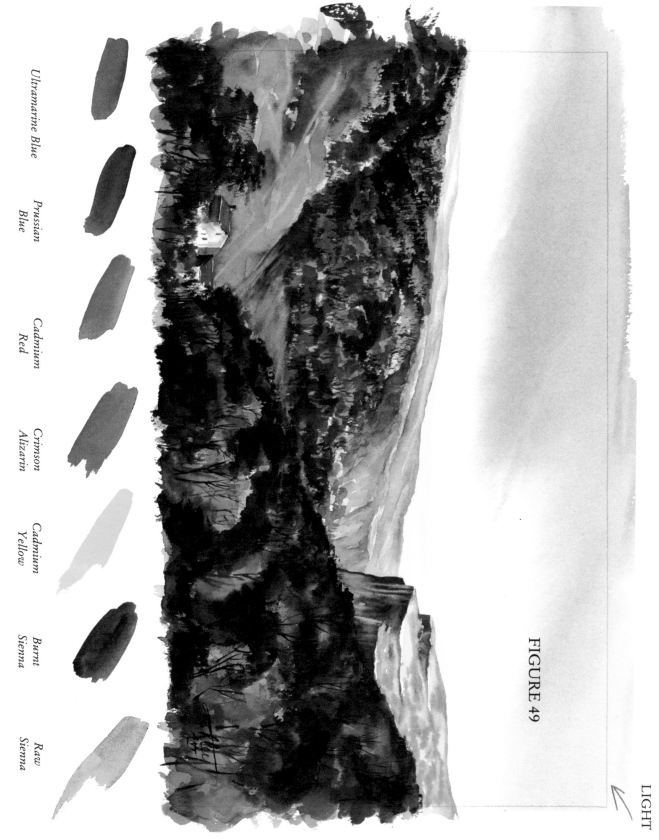

Ultramarine Blue

Prussian Blue

Cadmium Red

Crimson Alizarin

Cadmium Yellow

Burnt Sienna

Raw Sienna

FIGURE 49

LIGHT

Cheddar Gorge

71

cliffs. Using a mix of Ultramarine Blue, Prussian Blue and Cadmium Red, I painted vertically the cliff on the right-hand side of the valley. While this wash was still wet, I used a small moist brush to pull out the highlights, thus shaping the cliff.

By this time, I was really getting very excited with this exercise in tonal value and contrasting shapes. I proceeded to paint the clump of trees in the middle distance which was in shadow and seemed to be cooler in tone than the rest of the trees. Although it was a sunny day, there was still a bit of mist hanging in the valley which seemed to give a blue tinge to everything. I drew in the trees with a number 4 pointed sable brush using a mix of Prussian Blue, Ultramarine Blue and Crimson Alizarin, weakening the tone with more water as I put in the lighter tones, shaping the individual clumps. I achieved the individual trunks and branches of the trees with a dry brush which I flicked up lightly in the direction of the sky.

Watercolour is done economically in time and motion, and with the same technique as previously I painted in the dark areas of the right-hand side of the valley, which were now beginning to form my foreground.

Coming forward to the green hill on the left-hand side, the dark clumps were created with a mixture of Prussian Blue, Cadmium Yellow and a touch of Burnt Sienna, and was put to dry. From the middle distance to the foreground, I did not wet the area before I worked on it. Bringing this same mix down, I proceeded to do the trees in the foreground as well. With the grass bankings and the light green areas throughout the foreground, I added more yellow and less Burnt Sienna than with the previous mix. I washed in all the green areas throughout the foreground, for it is essential that you remember with watercolour that where the same colour reappears in your painting, you must put in all these areas together to achieve a harmonious look.

Using Prussian Blue with Cadmium Yellow I tinted in these bright areas and, while they were still moist, I used a moist sable brush to pull out the whites. Incidentally, you will see that there are two white buildings in the valley which I had to cut around as I applied washes, leaving them like white silhouettes.

When all the washes were dry, I used a mixture of Prussian Blue and Burnt Sienna for the trunks and branches of the more detailed trees. The leafy glades were of the same mix. To create the feeling of individual leaves, I used a number 4 pointed brush sideways on and flicked up very lightly.

I was now at the easy part of my painting, the shaping of the buildings – the detail everyone loves to do, the icing on the cake. I made the blue sky mix slightly stronger and I applied the shaded sides, before wetting the gable end with clean water and dropping in a weaker mix of the sky colour to this area. While this was drying out, I used Burnt Sienna with Cadmium Red for the tiles on the roofs. With a number 4 sable, I added in the details of the guttering and the windows, along with a few more trunks. These were to be my final strokes in my painting and provided the perfect finale to what had been a most exhilarating experience capturing the Cheddar Gorge.

ST IVES

I have had for many years a nightmarish memory of my last journey to St Ives in Cornwall, travelling at a snail's pace, bumper to bumper, down long and winding country lanes. The journey took so long and left me so tired and frustrated that I vowed never to visit again. As time goes by however, memories and feelings begin to fade, and for some time now I have simply remembered the highlights of that trip to this picturesque tiny fishing village set against the rugged Cornish landscape. I recalled the harbour view of St Ives, and the memory was so crystal clear that I decided that, no matter how long it took me this time, it would be worth going to see it again, and this time capturing it on watercolour paper.

I was a cold and crisp January day that I chose for my journey. The sharp lights of the day made me feel that once I was in my car driving, to stop and get out would be like opening a fridge door, where the light is so sharp and the air is so cold that it takes your breath away.

Driving down the A30 south from Exeter (see *Figure 50*), I began to appreciate what beautiful countryside lay ahead. I traversed the historic and breathtaking Bodmin Moor, which to my mind was a miniature replica of the vast moors that I have come to love so much in Yorkshire.

FIGURE 50

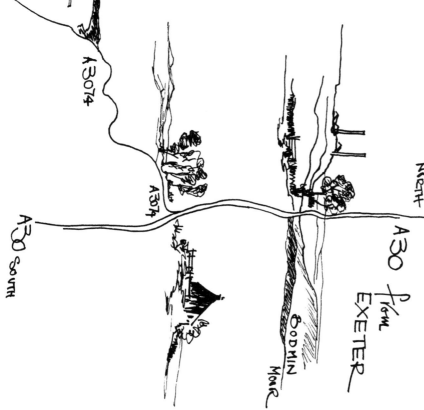

I was enjoying my drive to Cornwall on this day for I could not see another vehicle on this well-kept and well-made road. In parts it was so straight that it reminded me of the Roman roads that were once built as straight as a ruler.

I passed by tall chimneys that are the last reminder of the tin mines. They now seemed to come like candlesticks on a patchwork tablecloth, inviting me to dinner. I was really beginning to feel as though I was being welcomed to Cornwall.

The A30 through Cornwall takes you through some of England's most picturesque countryside, and is indeed a beautiful road to drive along. I could see why many artists such as Turner, Whistler and Sickert, and authors such as Thomas Hardy, DH Lawrence and Virginia Woolf were inspired in their works by Cornwall and its inhabitants.

Hundreds of people visit Cornwall each year, and never more so than since the epic *Poldark* was screened on television, telling the story of the Cornish Poldark family and showing some of the county's fabulous scenery there. I picked up the A3074 to St Ives, and I could not wait to get down to the water's edge. Luckily for me, being January and cold, St Ives was quite deserted and I had no problems parking down at the harbourside. As I began to acclimatize myself to St Ives, wandering along the harbour front, it began to rain, a light chilling rain that was not going to interrupt my expedition to this picturesque harbour.

I found the light on this day quite different, the rain was like crystals falling out of the Atlantic sky, reflecting the whole scene before me, making my subjects seem to dance in this sharp clear light. As the rain began to lift it made the Cornish slates glisten, and it was as though nature was playing table tennis with the light which was now reflecting and bouncing from all angles. Even the buildings in shadow reflected the light, and I found trying to trace the real source of light most confusing.

In *Figure 51* you will see that I have tried to capture with my 4B pencil the light and reflections that I was witnessing in this tiny fishing harbour. I wanted to sketch a fishing-boat which I discovered looking like a beached whale patiently waiting for the tide to invite it back into the high seas. I captured this lovely boat as I felt that one day it would stand as homage to the fishermen of St Ives and other Cornish villages when unfortunately, due to the economic climate, they will be a sight to be seen just in the history books.

Having depicted 'the whale', I began to walk into the town where a friendly local pointed out to me what is thought to be the oldest house in St Ives. As I quickly sketched it, I wondered whether Turner or Whistler had ever used it as a stay-over on one of their painting expeditions to the town. St Ives has become a haven for artists, attracting professionals and amateurs alike to capture and portray their feelings on canvas. The town has become world-famous as a centre for art: Bernard Leach established his pottery in the town, and Dame Barbara Hepworth lived here for twenty-six years until her death. Her Trewyn Studio is now a permanent exhibition gallery for some of her work. Many paintings over the years

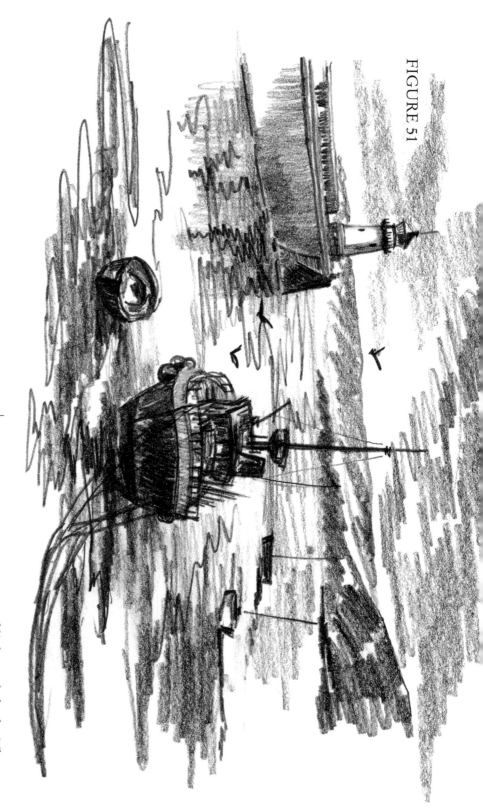

FIGURE 51

have been produced by the St Ives School of Art, from artists such as Ben Nicholson, Peter Lanyon, Terry Frost, Patrick Heron and Christopher Wood to name but a few. The Tate Gallery St Ives represents the great effect that the town has had on artists, and all the work in this building was created in, or influenced by Cornwall.

My rough sketch of this old building *Figure 52* was captured with my broad felt-tip pen. A technique I used on this occasion was to use up the ink on the foreground detail and shape so that I could

achieve a strong contrast of light and shade. Then, when the felt-tip was drying out, I put in the background and soft shades, thereby giving my composition another dimension.

St Ives is full of nooks and crannies and picture postcard scenes. Houses appear to elbow up to other cottages. In *Figure 53* I decided to capture with my Burnt Umber conte crayon this little white building that contrasted so greatly with the Cornish slate building next to it. If you are what I call a 'finicky artist' who likes to add lots of

unwanted detail into your composition, you will find that working with conte crayon really loosens your work, because it is difficult to achieve a lot of detail with a conte crayon.

As I wandered down the back streets, I felt momentarily as though they were beckoning to me to see what they wanted me to view. I fought loose of the control of these streets though, and came across a breathtaking view of this lovely bay with the small cliffs and golden sands of Porthmear Beach. I felt compelled in *Figure 54* to put my inspirations and delights down on paper, and capture the moment in time before it disappeared. I did this by using the conte crayon which I found skated over the cartridge paper quite easily, and the texture of the paper combined with the light pressure I applied created the feeling of the sand, sea and clouds that were before me.

I retraced my steps towards my car to get my paints. I then produced this working sketch, *Figure 55*, of the harbour and its houses with my drawing pen. You will observe from the sketch that I have included in my composition the lighthouse, the harbourside and the buildings of St Ives. The photograph that I took only captures the buildings as my camera lens could not stretch to include the lighthouse. This is a perfect example of how limited a camera can be when composing a picture for those of you who wish to paint purely from photographs. You will see that I have placed three arrows in the sky of this working sketch, and the word 'light'. I did this as I was delighted to have found the source of light, at that moment originating from a break in the clouds. I was at this point getting very excited at the prospect of capturing St Ives in watercolour.

Many of the paintings I have seen of St Ives have depicted the town in pretty summer clothes. I mean no disrespect to the artists who have depicted her in that way, but to my mind these summer pictures are nearly all chocolate box covers. I wanted on this occasion to paint St Ives in a dramatic mood, capturing the sea and the sky in a powerful way to convey the feeling of the elements that the fishermen of this town have to battle against in their daily life; the houses and cottages in my composition being their refuge.

The scene had truly intoxicated me, and I was now ready to spill out my thoughts and energies and record my feelings about St Ives on watercolour paper. I knew that I had to work fast as the tide was coming in, dusk falling and the winter light disappearing. I wanted the gaily washed cottages to be a banner of colour in my picture, starkly contrasting with the sky and the water. The boats I wanted to appear like bobbing coloured corks in the water.

You will note that I have included on the right of the horizon, the cliffs of Cornwall, which the camera could not capture, but the human eye could. Through the lens of a camera these cliffs looked like black snakes, pure thin black lines; but the eye could see the tone and depth in them. If you want to be able to capture with paint, the landscape, please treat your camera like a drug, sparingly, for the camera cannot replace the human eye. It does not have feeling; it is clinical, cold and soulless.

FIGURE 52

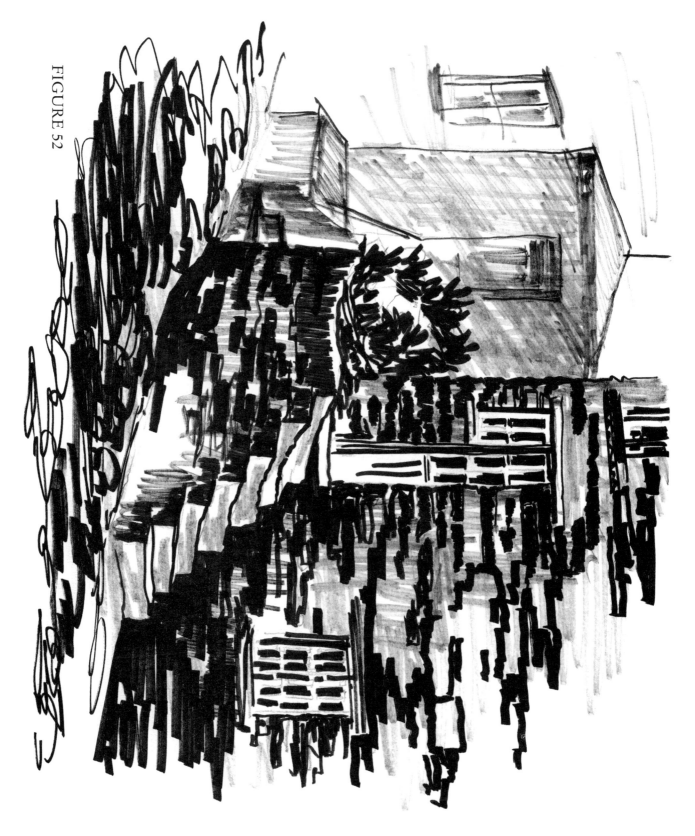

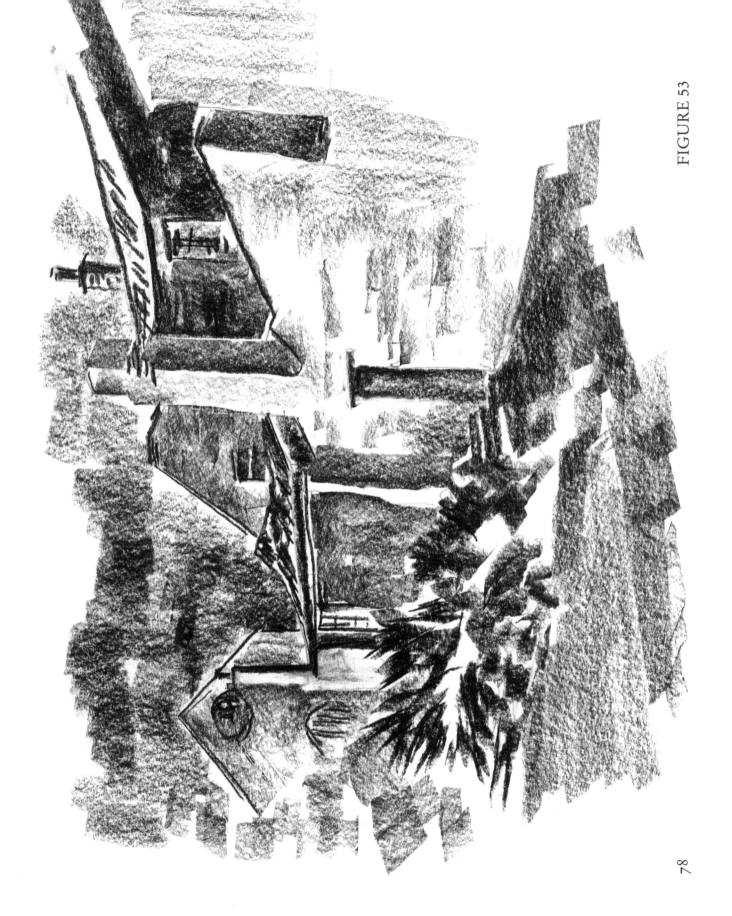

FIGURE 53

Bearing in mind my sketch, *Figure 55*, showing the source of light, I started *Figure 56* by sketching in lightly with my 4B pencil the composition and the detail, as well as the shape and light on the water.

On 140lb (300g) rough rag paper, I washed in the sky with clean water, leaving the area of light dry. Working quickly, I made up a sky colour with Prussian Blue and Ultramarine Blue and a little pinhead of Crimson Alizarin, and the same amount of Burnt Sienna. Putting the wash in, and

following the tracks of the previous wash of clean water, I laid in the sky with a moist extra wash brush to mop up and feather in the soft cloud.

Using the same technique for the harbour, washing in with water followed by the sky mix colour in this area, I put in dark tones forming a river of light, being careful not to block out any of the light I needed. In the foreground you will see that I have used the corner of the wash brush to form the dark shadows of the incoming tide, thus giving me some perspective in the harbour.

FIGURE 54

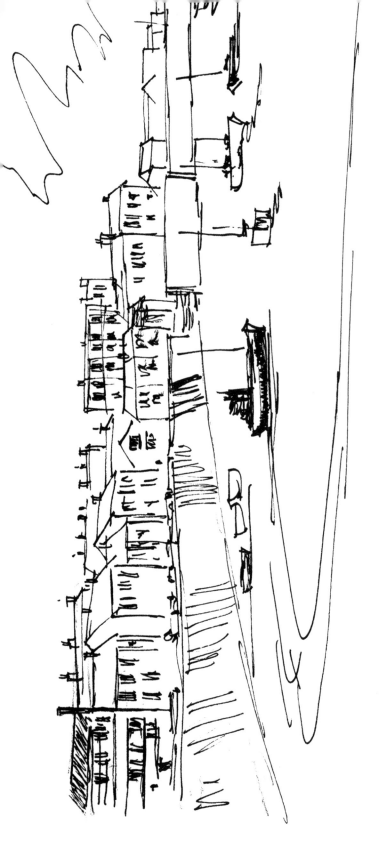

The lighthouse in the distance was shaped by the sky. I left a patch of white for the lighthouse by simply cutting in with a number 6 sable pointed brush as I painted the sky. You will note that I did not use any masking fluid to achieve this effect; it is a matter of mastering your tools. With watercolour painting, it is the background washes that shape the foreground, and in this case the lighthouse is the foreground of the sky. You will observe that the same technique is used on the houses on the harbourside, as well as for the boats in the harbour.

Mixing the sky colour with a little more Prussian Blue and Burnt Sienna, I painted in the harbourside where the lighthouse stands, leaving a pin-line of light between the sky and the harbour edge, just in case the sky wash exploded. This also gave me reflected light on the harbour wall. Using the same colour, I put in the dark roofs and gable ends, which automatically shaped the light tone buildings. While the washes on the buildings were drying, I used a very weak wash of Burnt Sienna and Prussian Blue to form the foreground and harbour walls. I then went back to the water in the harbour and gave it another wash of sky colour; with this wash I got a dry ½in (1.25cm) chisel edge brush and dragged the surplus water vertically down. The reflections in the foreground of the picture were flicked up vertically using the same technique.

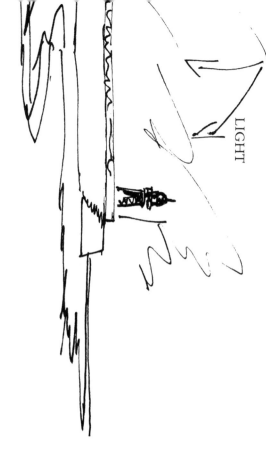

LIGHT

FIGURE 55

Returning to the buildings, I used a mixture of Cadmium Yellow and Cadmium Red as tints which I put in on alternate buildings, creating a mixture of colour, sometimes using stronger tones to create brighter effects.

The buildings in the far distance were created with the dirty water in my palette which was a mixture of tints of red, yellow and blue. Now I was ready for the detail of the buildings and lighthouse. I again mixed a sky wash, this time using less water and more pigment, to give a cold, dark tone. It is this mixture which I used to shape the lighthouse and its detail, the buildings following on from this.

Using a dry chisel brush with this same mix, I started at the top of the harbour wall and then dragged my brush vertically down to create the feeling of texture and growth that was on the walls. I put in detail with a number 3 pointed brush using the same mix for the gutterings, windows and any other detail on the harbour front. I then progressed to the boats, painting in the shadowed sides first and the masts with the sky colour mix. When this was dry, I painted in the boats with tints of reds and blues. Using the blue wash of the harbour which comes from the sky mix, I tinted in the dark shadows of the water around the boats. I have always said that watercolour painting is like painting with coloured sheets of glass – you have to wait until one dries before putting the other one in (unless of course you are using a wet on to wet technique). With this in mind, I used Cadmium Yellow with a hint of Cadmium Red and washed in the source of light in the sky very delicately. I then washed in the area where the sky colour was reflected in the landscape, and the harbour, with the same colour.

When the buildings were dry, with my dry chisel edge brush and a weak wash of the sky colour, I dragged down very lightly, at an angle of 45 degrees, the wash to give the impression of the shadows and clouds that were looming over the buildings. When the surface of the paper was completely dry, I proceeded to put in details of the mast, railings and some of the windows with a stronger wash. I then added, as a final touch to my painting 'The Welcoming Light of St Ives', three silhouetted seagulls. I was so pleased that I had finally made the effort to return to St Ives.

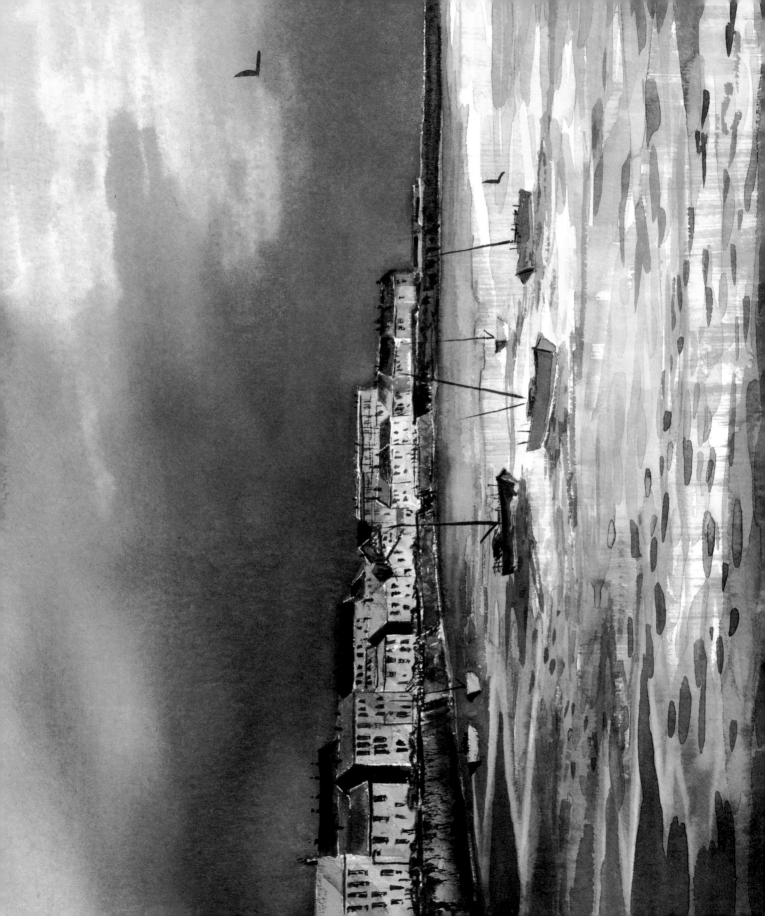

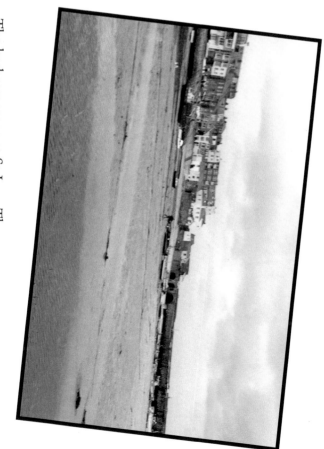

The harbour scene at St Ives. The photograph (above) again demonstrates the limitations of the camera in both scope and detail.

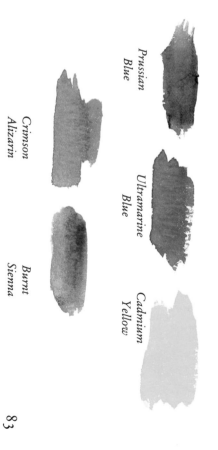

Prussian Blue

Ultramarine Blue

Crimson Alizarin

Burnt Sienna

Cadmium Yellow

FIGURE 56 The Welcoming Light of St Ives.

DEDHAM AND FLATFORD

inspired, although coming from the Pennines, the backbone of England, I find that the flat country in the south of England often makes me feel claustrophobic. I am used to a large vista where I can see forever. Flat landscape reminds me of the sea; even with all its power and beauty it only allows you to see for 20 miles (32km) at the most, whereas my vistas usually extend up to 100 miles (160km). I was fighting the feeling of wanting to jump up and down to be able to see the next hedge. However, I can understand the beauty in this part of the country does hold some interesting and beautiful scenes. A common feature of the area is the winding river scenes that you will see with tall trees flanking them, the trees appearing like tall and graceful ballerinas. Constable said of these river scenes, 'As long as I am able to hold a brush, I shall never cease to paint them.' Constable was born in 1776 at East Bergholt, which is not very far from my first port of call, Dedham, lying on the banks of the River Stour. Constable came from a very prosperous family and his father owned a mill in Dedham, while the junior Constable worked in his father's second mill at Flatford. The 131ft (47m) fifteenth-century church that I captured in ink at Dedham, *Figure 58* was one of Constable's favourite subjects; I too was captivated by it.

The composition of tree and river with its reflections in *Figure 59* caught my eye and was

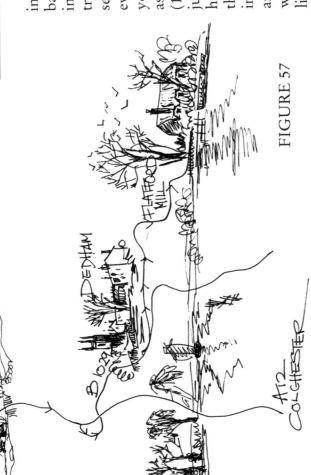

FIGURE 57

I drove from Ipswich on the A12 then on to the B1029 towards my destination of Dedham and Flatford (*see Figure 57*), two neighbouring hamlets. My journey took me through landscape that was very soft and gentle to the eye. It was as though Capability Brown had arranged all the trees!

One of our great landscape painters, Constable, said of the countryside around the borders of Suffolk and Essex that 'these scenes made me a painter'. I can appreciate why he was so

only a short walk away from the church. The tree reminded me of a native American's headdress, and the water shining looked like a polished crystal. I caught this reflecting water by drawing in with pencil the reflections of the bankside and the sky, and then with my putty rubber, cleaning out the area where the river and bankside met. I also created, with the putty rubber, the zig-zag effects of reflecting light on the river. The shape and depth of the river was created by vertically rubbing downwards the lights with the rubber. So you see, rubbers come in handy not just for correcting mistakes, but also to enhance your work.

I was fascinated with the lock-keeper's house and the lock at Dedham, as well as the trees that flanked them. I captured this scene in *Figure 60* which is an interesting sketch showing the play of light.

Leaving my car in Dedham, I walked across this pastoral countryside along the banks of the River Stour, the few miles to Flatford. This little hamlet on the Suffolk bank of the river was the subject of four of Constable's paintings, all of which, I am pleased to say, survive. The thatched cottage is the only one open to the public and is now a café, and the Mill, Mill House and Willy

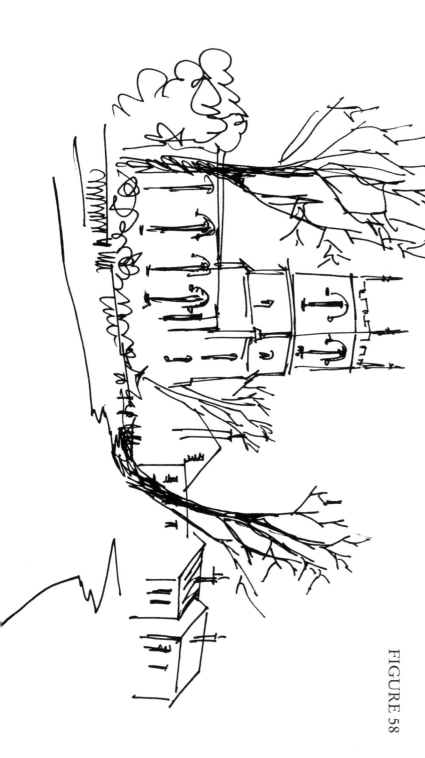

FIGURE 58

Lott's Cottage (the latter was exhibited in Paris in 1824) are now leased to the Field Studies Council. The buildings and landscape have changed very little since the days of Constable. I, like Constable, captured Willy Lott's cottage, but I did so with pencil instead of watercolour as can be seen in *Figure 61*.

I found the thatched house and footbridge to be a most interesting subject. It took me back to my days in the Orient and the story of the Willow pattern. It was the shape of the bridge that made

FIGURE 59.

me think of the story of the two young lovers who were chased across the bridge by their parents, who disapproved of the relationship. The bridge for the young lovers became a place of no return with parents on either side of the bridge, and it was at this point that the two transformed into doves of love and flew into the sky, thus escaping their parents. Although I know that the scene in Flatford was thousands of miles away from the origins of this story, I believe that it was the oriental shape of the bridge over the River Stour that allowed my imagination to run away with me.

Figure 62 shows clearly my rough pencil sketch of the composition, and most importantly of all, it shows you the direction of light at the time. The photograph of this scene also shows some of the ducks and swans that were featured in my drawing, for this area supports a variety of wildlife, but in my final painting I chose to leave out these birds as I felt they would make the composition look too twee.

While drawing in my final composition *Figure 63* very lightly with the pencil, I fell in love with the tree on the left-hand side of my painting as it seemed to frame the painting and mask the cottage. The tall, distant trees stood like statues in porcelain. When I had finished the drawing, I mixed a sky colour of Prussian Blue with a little pinhead of Cadmium Red, and applied this mix, after washing the sky area with water first. I dropped this colour in from the top of the paper, working the colour down to the horizon, making it gradually weaker as I did so. With this same

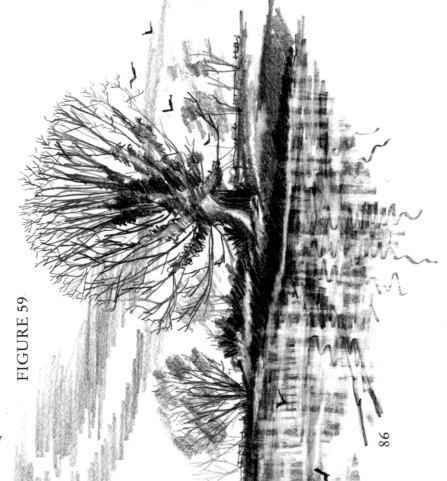

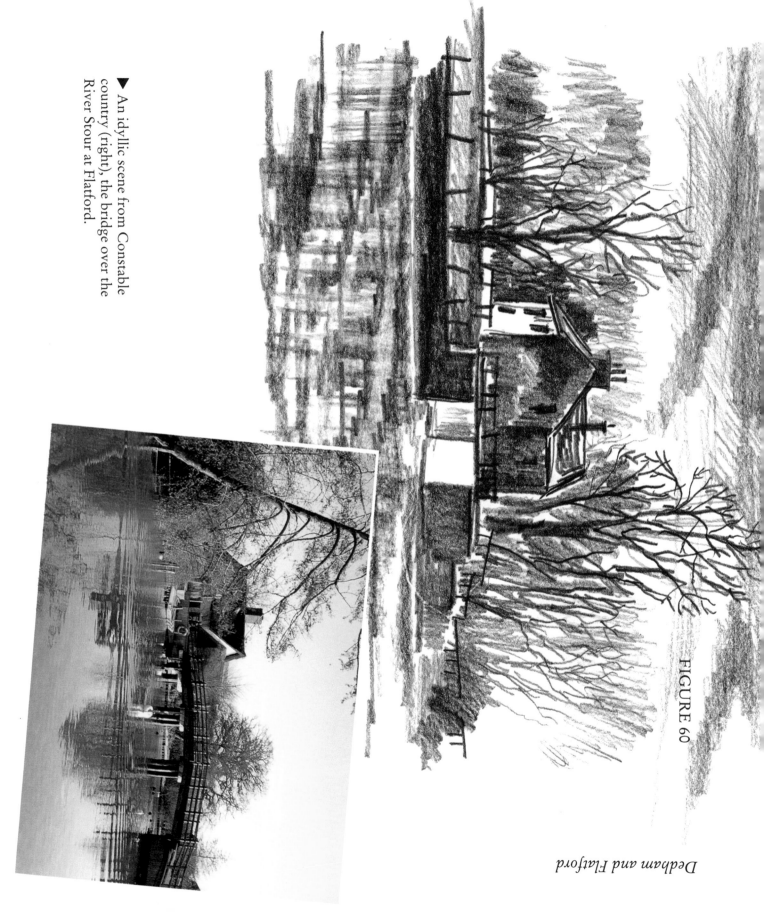

▶ An idyllic scene from Constable country (right), the bridge over the River Stour at Flatford.

FIGURE 60

Dedham and Flatford

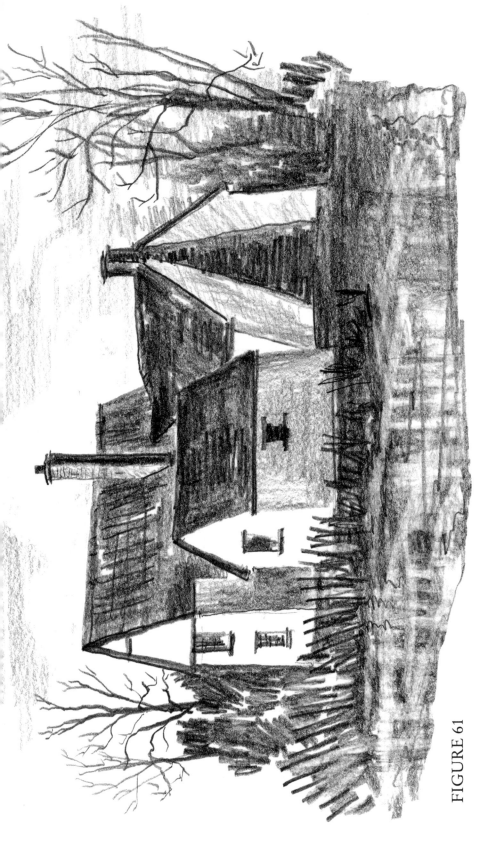

FIGURE 61

mix, I tinted in the water of the river, and when the sky area was dry, I added in the distant trees.

My key colour in this painting was to be Prussian Blue, and I was going to add this to all my colours that I used in this painting, just like a cook would add a pinch of salt to the ingredients. Whether for the roof or trees this colour would be there, harmonizing the painting and making it look as though it had all been painted in one day.

The colour that I created for the thatched roof was made up of Burnt Sienna with a touch of Cadmium Red, not forgetting my 'salt' of Prussian Blue. With a weaker mix of this colour I also added in the buildings on the right-hand side of the picture. The next stage was to add in all the lemon green areas of my painting. To get the colour that I wanted for these areas, I mixed Lemon Yellow with Prussian Blue, and when that was dry I mixed Prussian Blue and Burnt Sienna to paint in all the foliage in the foreground. For

the trees in the distance I used a weaker mix of this colour.

Whilst waiting for everything to dry, I mixed Prussian Blue with a touch of Burnt Sienna to form the outline of the shadows in the water. A stronger mix of Prussian Blue and Burnt Sienna was then added to the thatched roof. The chimney stack on the shaded side had more blue in it, and on the light side of it, I added a touch of Cadmium Red to give the hint of a brick chimney. With this chimney mix, I painted in the darks of the poles in the water, the shadows on the river, the tree trunks and the windows in the house.

When all was dry, I cleaned out areas to form lights with a moist chisel edge brush (this is a good tip as you can clean out when dry as well as moist). I used this technique to give the feeling that the light was catching areas such as the poles in the river, the trunks of the trees and the reflections on the water. With Lemon Yellow, I added a little touch of Ultramarine Blue and applied this to the cottage wall. I used the same colour to wet

FIGURE 62

LIGHT

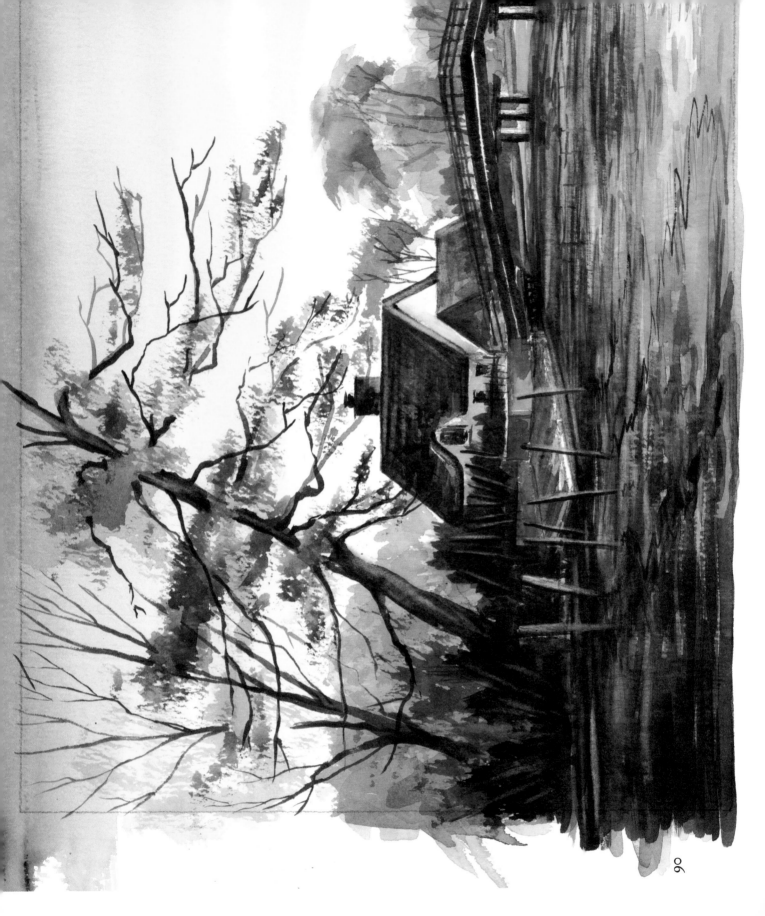

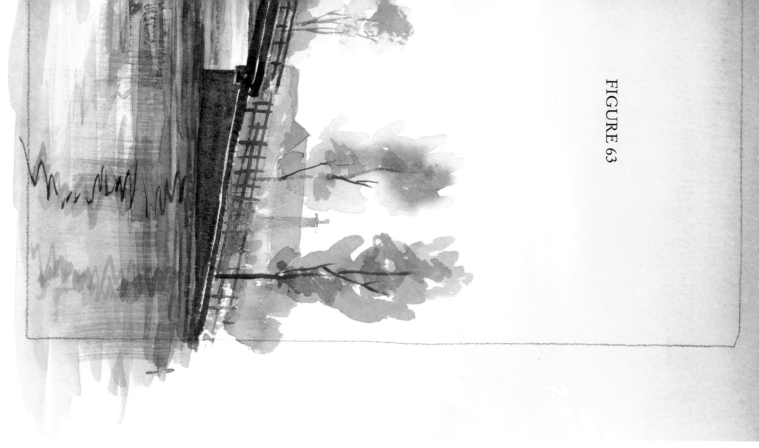

FIGURE 63

over the far distant trees to give a feeling of warmth to my painting.

My final work was on the trees on the left-hand side which, as I have said before, were an important feature in the painting. The final foliage was done with a pointed dry brush which I used lightly sideways, picking up the textures of the surface of the paper to form individual leaves. When this was dry, I put in the branches with a dark mix of Prussian Blue and Burnt Sienna. The technique for foliage is simple, and if you use common sense, you cannot go wrong. Leave gaps in the tree trunk so that the foreground foliage can be put in at a later stage. All the tree branches and finer details were created with a number 3 pointed sable brush. The final strokes on this painting, which I have titled 'Oriental Air to a Constable Landscape', were the stronger reflections on the water, which I finely drew in with my brush.

This area holds an abundance of scenes for the landscape painter, and I am sure that you will have many hours of pleasure capturing in watercolour your chosen scene in Constable country.

Prussian Blue *Lemon Yellow* *Burnt Sienna* *Crimson Alizarin*

RICHMOND UPON THAMES

On this journey I was going to travel the well-trodden path to Richmond in Surrey, a path that for over 800 years artists, monarchs, poets and last but not least, the common man – myself included – have trod, many of them choosing to live in this rural corner of London.

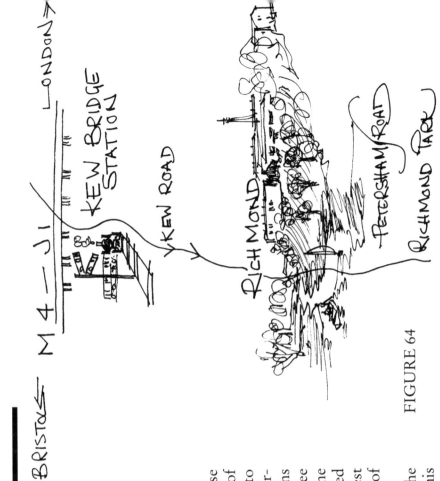

FIGURE 64

Richmond upon Thames is situated very close to London. Lying just a few miles south of junction 1 of the M4, it could not be easier to reach, especially as, once you have left the motorway, you simply follow the well-directed signs and reach your destination relatively hassle free (*Figure 64*). There really is no excuse for anyone not to journey to Richmond as it is positioned midway between Heathrow Airport and the West End of London, and it is even within easy reach of Gatwick Airport.

Richmond is known as the place 'where the countryside comes to town' – I chuckled at this thought as I drove along, as it occurred to me that having just staggered from the chaos of fume-filled London to get my first breaths of almost pure air, the countryside was hardly the last thing that I had driven through to get to this destination. Jokes aside, I can understand why artists of the past who lived in London, escaped to this picturesque English town with its beautiful eigh-

teenth-century architecture – architecture which shows elegant and clean lines. Such a pity that the twentieth century did not take note of the elegance of these past masters. Style is here to stay but fashion unfortunately fades away.

I felt welcome as I walked the tree-lined streets of Richmond close to the famous Richmond Park,

FIGURE 65

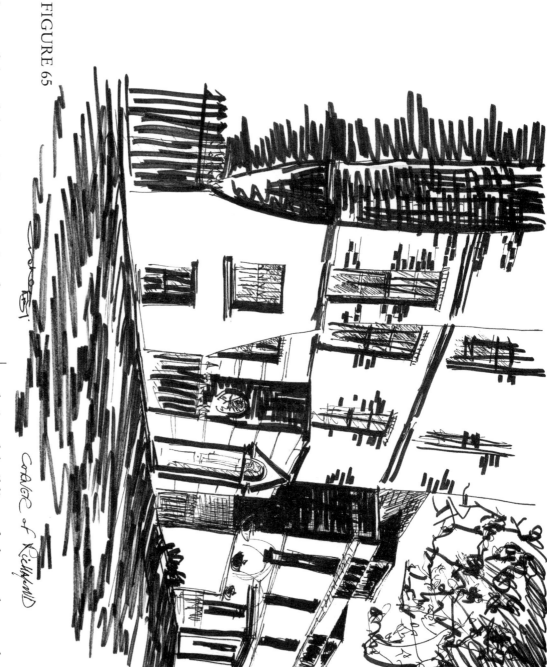

home of the red deer. As I was enjoying the tran-
quil atmosphere and viewing the splendid archi-
tecture, I came across the former home of the late
Joshua Reynolds, one of England's most magnifi-
cent painters. Situated at the top of Richmond
Hill, the house is now a home for disabled sol-
diers, sailors and airmen. This razor-blade

designed building of sharp edges and clean-cut
corners stands like a memorial to Reynolds. I cap-
tured it with my marker pen in *Figure 65*, using
the corner of the pen to achieve the finer lines.

Richmond Hill is a high plateau, and once you
are at the top of it, you almost feel that once upon
a time the whole landscape around used to be just

FIGURE 66

one flat landscape. Where the River Thames now lies at the bottom of the hill, I got the feeling that the land had dropped a few hundred feet to create a doorstep landscape. You will understand what I mean when you visit it, for the top step is the town of Richmond and the bottom step, the River Thames.

Making my way around Richmond, discovering other picturesque landscapes and views to sketch, I came across a pub which I feel I was as much drawn to by the fragrance of the Yorkshire Bitter on draught as I was to the view! This pub was at the bottom of the hill, and it was one of the few that sold this nectar of the north.

What I loved about this particular corner was its tall, perfectly-shaped trees, a feature not often seen in my beloved Yorkshire because of the elements that they have to withstand. I captured this quiet corner with my 4B pencil in *Figure 66*, making it an exercise in tonal value. Later, walking

along Petersham Road, I could clearly see a lovely view of Old Father Thames, and the graceful tree in the foreground made a perfect L-shaped composition. It was as though Turner and Reynolds were sitting on the hill observing every mark that I put on my cartridge paper, and I felt almost like a young schoolboy watched by my tutor. I took out my 4B pencil and began *Figure 67*. I used the side of the lead to give me the finish; the same effect would have been derived from using a chisel edge brush.

Making my way back up to Richmond Hill, having found plenty to sketch but no view yet inspiring me to take out my watercolours and paint, I came across the wonderfully shaped and palatial Petersham Hotel, with its London brick and red tiles, *Figure 68*. From here I could view the Thames below eye-level, not as in *Figure 67* where it lay at eye level. I captured this scene again with the 4B pencil – as you will appreciate by now I love doing tonal value sketches. I believe these exercises help you to see your subject in tone rather than outline.

Once I finally reached the top of Richmond Hill, I sat on the terrace resting a while. I was seated on one of the many benches thoughtfully provided for those who wish to admire the vista, and it made me think of my dear friend and primitive painter, the late L.S. Lowry. It was he who told me that he advised the painter Helen Bradley to put people in her landscapes. She was known for her series of paintings cataloguing Victorian life called 'Miss Carter wore Pink'. I felt as though Miss

Carter and her friends could have been with me now, promenading with their parasols on this beautiful terrace, sharing the view. I was aware also that the great English painter Turner must have once sat within a few feet of where I was going to capture in watercolour my painting, for he had composed one of a similar view of Richmond.

This composition is good, and a fine example of the horizon line marrying with the eye-level line, for even though we are looking at the view from high on Richmond Hill, the land we are looking at is flat. It is the same situation that you would get if you were to paint from, for example, the cliffs of Scarborough and were looking out to sea. Once you can appreciate your eye-level and horizon lines you will feel more at ease executing this type of composition.

The River Thames is a major feature in this painting, for its appearance breaks the monotony of the flat landscape. Rivers and streams can be very tricky to paint, and many painters who know nothing about eye-level and perspective make their rivers and canals appear to be flowing uphill, or even worse, sticking up out of the painting like a pop-up birthday card. The reason for this is that their river has been put in well and truly above their eye-level line, causing it to take off into the sky. You must ensure that these subjects are composed below your eye-level line and so create a painting with features that do not look out of place.

With this in mind, I began to put paint to paper, washing in the sky as always with clean water, up

to the shared horizon/eye-level line. While this was drying to a damp stage, I mixed Ultramarine Blue with Prussian Blue and added just a pinhead of Crimson Alizarin. I then applied a 2in (5cm) band of this wash at the top of the sky. Mixing Burnt Sienna and Cadmium Yellow, making it into a Raw Sienna, I washed in the remainder of the sky. As the paper was damp, these two bands fused together naturally, but I helped them along with my wash brush to create a graduated wash.

Using the same wash brush, I cleaned it of any paint, and mangle-dried it with two fingers, leaving it moist. I was able then to wipe out areas of the sky to form wispy clouds.

In painting scenes like this, I am always aware of the 'vanilla slice syndrome' – that is where you get bands of horizontal colour fighting against one another to take first place in your painting, so distorting the painting. What you must do to get away from this, is to remember how you set your composition out, that is foreground, middle distance and distance. The foreground must take first

place as it is nearer to you, then the others will follow through. This painting for me was not only going to be an enjoyable experience, but an exercise in colour perspective and tonal value.

Only by keeping colour and tonal value in mind will you get flat ground to appear to lie down, as tone and colour should recede into the distance. This is a useful tip when attempting to paint such things as cricket fields for I have seen many such paintings where the players appear to

FIGURE 67

FIGURE 68

be glued on to a green backdrop. When painting such a subject, you must have strong colours and tones in the foreground, weakening them as you recede into the far distance. If you follow this approach you will find that your subject will automatically appear to lie down.

Working from my eye-level line, I used a sky mix of Ultramarine Blue, Prussian Blue and a touch of Crimson Alizarin for the distant fields and hills, working towards the middle distance.

With the middle distance, I used slightly more Prussian Blue in the mix to achieve a slightly greener effect. I worked with these tones on either side of the river, leaving the river for a moment as a white area of paper.

The technique that I used in *Figure 69* was a dry technique, in other words I did not wet the area before I placed on my wash, and I left each wash to dry before I added another to it. Today nature was working with me; it was a dry day with no

Richmond upon Thames

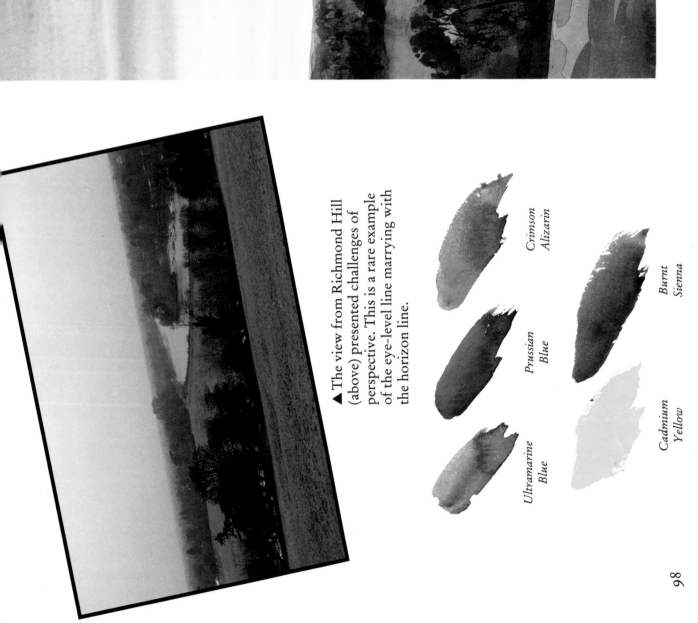

▲ The view from Richmond Hill (above) presented challenges of perspective. This is a rare example of the eye-level line marrying with the horizon line.

Crimson Alizarin

Prussian Blue

Ultramarine Blue

Burnt Sienna

Cadmium Yellow

FIGURE 69

Richmond upon Thames

damp atmosphere, so this technique was ideally suited to the weather. The scene required a more detailed, delicate and softer approach than that of a scene such as Glen Coe for example, so this dry technique was perfect.

Once the fields in the middle distance were dry, I added a wash of Cadmium Yellow, Burnt Sienna and a pinhead of Prussian Blue. The shadows on the field were created with the same mix, but I added to it slightly more Prussian Blue and Burnt Sienna.

Using the blue sky colour mixture, I painted the river to form cloud shadows and reflections, just tinting it in its shaded parts, leaving the highlights as the white of the paper.

Coming forward to the foreground trees, I put in a mixture of Burnt Sienna and Prussian Blue for the first wash, and then used the same wash to do the front line of trees in the middle distance. I made the wash slightly weaker, remembering that the middle distance was secondary to the foreground. When painting trees like this, it is a good tip to think of trees as being like soldiers on parade: the ones in the foreground look very sharp and crisp, but as they recede into the distance, they all become a blur of colour with not much detail visible. This thought will prevent you from being too detailed on every tree. As I went into the far distance with the trees, I used a stipple technique with the same colour mix, but added a lot more water to weaken the tone and provide a misty feeling, with only the odd clump of trees showing. The stipple technique I always liken to a large bird pecking for grains or seeds: the brush

hits and misses the paper intermittently to give this wonderful effect.

The bankside and the far side of the river were done in the same way, so shaping the river's edge. The trees were given three or four washes to shape them. When the rest of the washes were dry, I used a number 3 sable to paint in the details of the trunks and branches. You will see that I have left gaps in the foliage: you will notice that in reality there are always such gaps, which enable the birds to fly through the trees without breaking their necks!

I wanted to give the feeling of having a slight slope to the foreground field and, remembering that in colour perspective the foreground comes first, I gave it all the power in colour that I possibly could.

I mixed together Cadmium Yellow with a touch of Prussian Blue for my first wash. Letting this first wash dry, I then applied the cloud shadow in Prussian Blue with a touch of Burnt Sienna. This not only shaped the picture, but gave it a little more character.

I titled this finished painting 'My Vision of Turner in Richmond'. I thoroughly enjoyed my day down at Richmond where I found the landscape to be soft and picturesque. Having had a full day there, I can fully appreciate why this riverside town attracts poets, artists and monarchs alike.

My journey across Britain was well and truly taking me to the most varied, interesting and picturesque places. I was savouring and loving every moment, as I hope you will too.

PENDLE HILL

FIGURE 70

Pendle Hill lies some twelve miles from Skipton. The hill and its outlying areas have been steeped in witchcraft. It was in 1612 that 12 witches from the farms and villages around the hill were sent to the scaffold. Two of the witches, Demdike and Chattox, were accused of casting spells on the terrified inhabitants of Newchurch. In fact, when you visit this village at the foot of Pendle Hill, you will notice 'the all seeing eye of God' on the church tower. This was supposed to have protected the worshippers from the witches' wiles! Pendle Hill is not to be remembered just for its witches; while George Fox was walking the hills of Pendle, he had his first vision of forming a society of friends, later to be called the Quakers.

With these thoughts in mind I set out on what was one of those rare, glorious summer days in Britain, with not a cloud in the sky. I headed from Nelson and Colne on the A682 towards Blacko. Turning left, I followed the signs to Roughlee (*Figure 70*). You will find that this road winds through some of Lancashire's most picturesque hamlets and villages, including Newchurch and Barley, where rivers and tall trees cluster at the bottom of Pendle Hill wandering round it like a daisy chain.

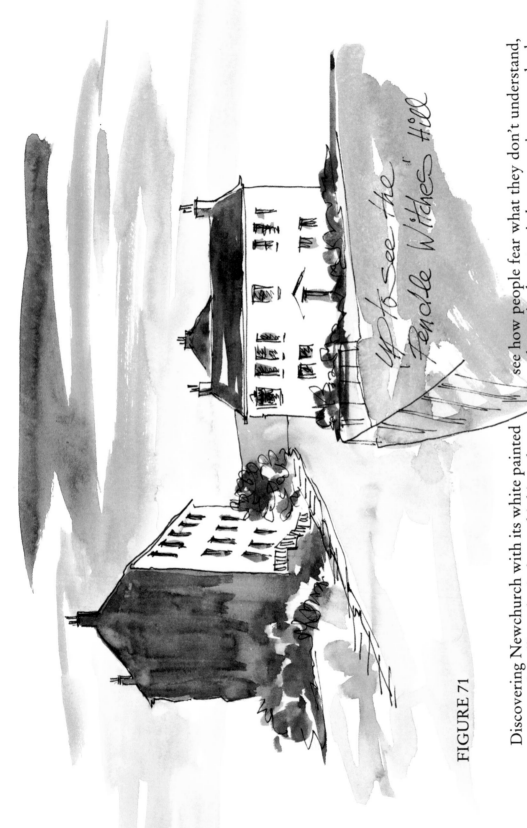

Up to see the 'Pendle Witches' Hill

FIGURE 71

Discovering Newchurch with its white painted cottages and mullioned windows, thinking about the history and nature of Pendle, and drinking in the natural beauty of Pendle Hill like a fine wine, I soaked up the atmosphere and felt the touch of Pendle's past. My mind dwelt on the 12 accused witches of Pendle. Had they really been wicked and evil, I wondered, or were they innocent victims of mankind's ignorance. Even today we can see how people fear what they don't understand, and even in the twentieth century, ignorance leads to prejudice.

As an artist I like to think that I have become very close to the natural elements, feeling at one with them in order to portray on my paper the true atmosphere that they provide. If the story of the witches is true – and I would like to think it is – I realized that they had been closer to the

FIGURE 72

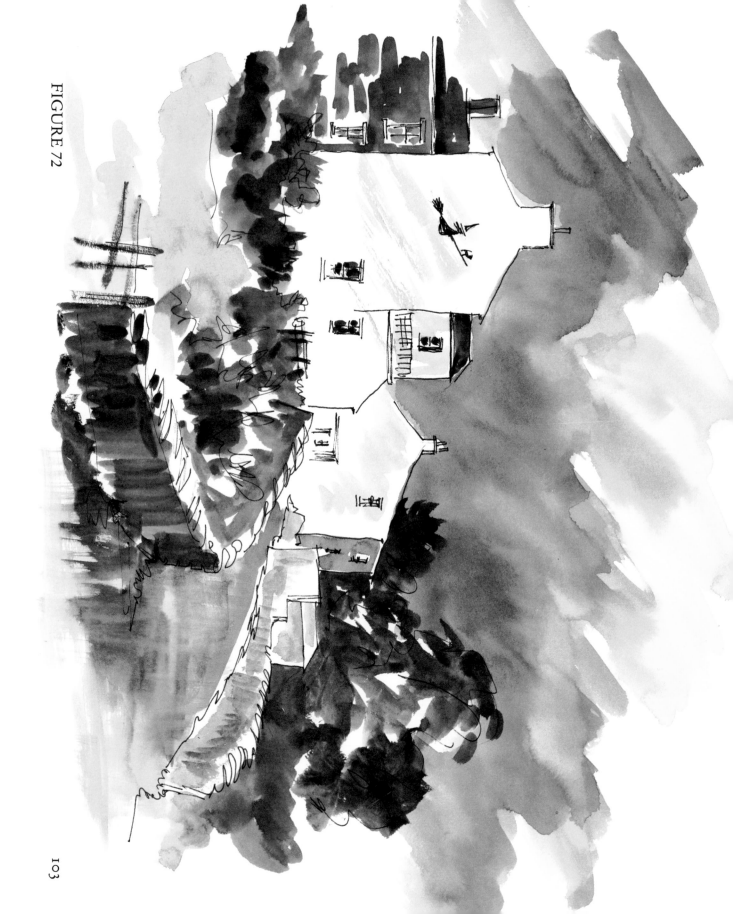

natural elements than I could ever imagine. Momentarily, as I looked up towards the hill, I felt that I had a hotline to Shakespeare's *Macbeth*, imagining the witches huddled around their cauldron, mixing potions in their 'hubble, bubble, toil and trouble' kind of way.

With this thought, I began to make notes in drawing. I felt that to do a sepia monochrome was the ideal medium (and that is not a spiritual pun!) to portray the feeling and atmosphere that was beginning to engulf me. I had said earlier that it was a bright sunny day, but the witches still seemed to cast a shadow over the village of Newchurch, almost as though they were drawing me into their secret coven.

The advantage of using monochrome is that it

FIGURE 73

FIGURE 74

gives an ink drawing added depth through the use of light and shade, and instantly achieves the atmosphere that you wish to create. It is for this reason that it is essential to practise monochromes, as it is the only way that you will learn to achieve atmosphere and begin to grasp the art of painting. As you can see, the practice need not be a painful, laborious task – here I was practising on my day out. Make practice a lovely journey for yourself: think of it as making visual letters in the book of life.

I maintain that we all have our own feelings and individual expressions, and how one interprets a different vision may be entirely different to someone else's interpretation of the same subject. A person without feeling is a very exceptional and dangerous one. You will discover that sepia monochromes are an ideal way in which to put your feelings on to watercolour paper.

I have named *Figure 71* 'Up to see the Pendle

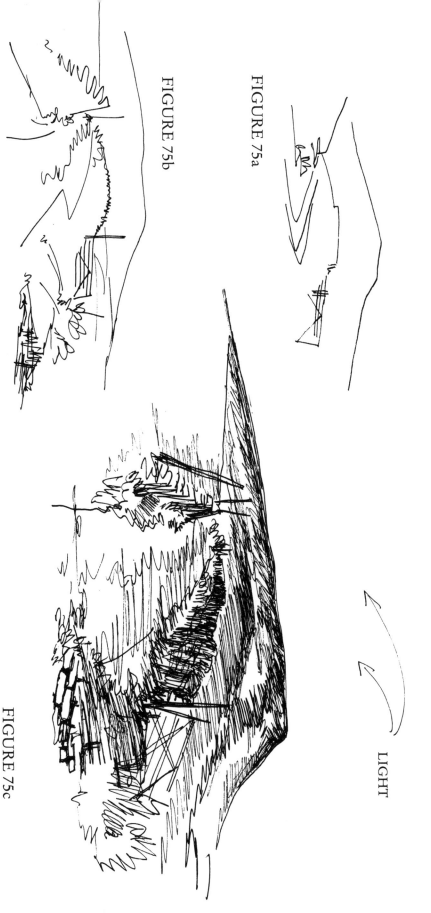

FIGURE 75a

FIGURE 75b

FIGURE 75c

LIGHT

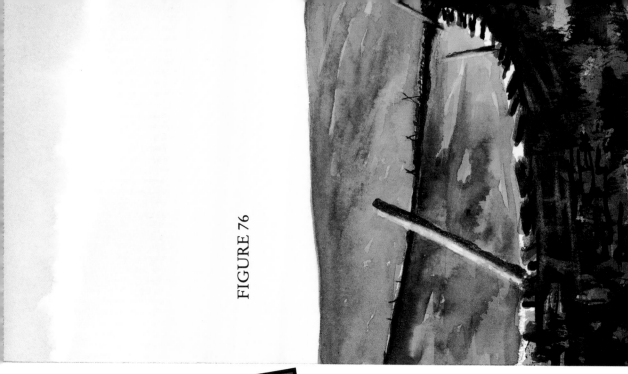

FIGURE 76

Compare the photograph (above) with the painting (right) to see how minor alterations to detail can improve a composition.

Lemon Yellow

Burnt Sienna

Prussian Blue

Ultramarine Blue

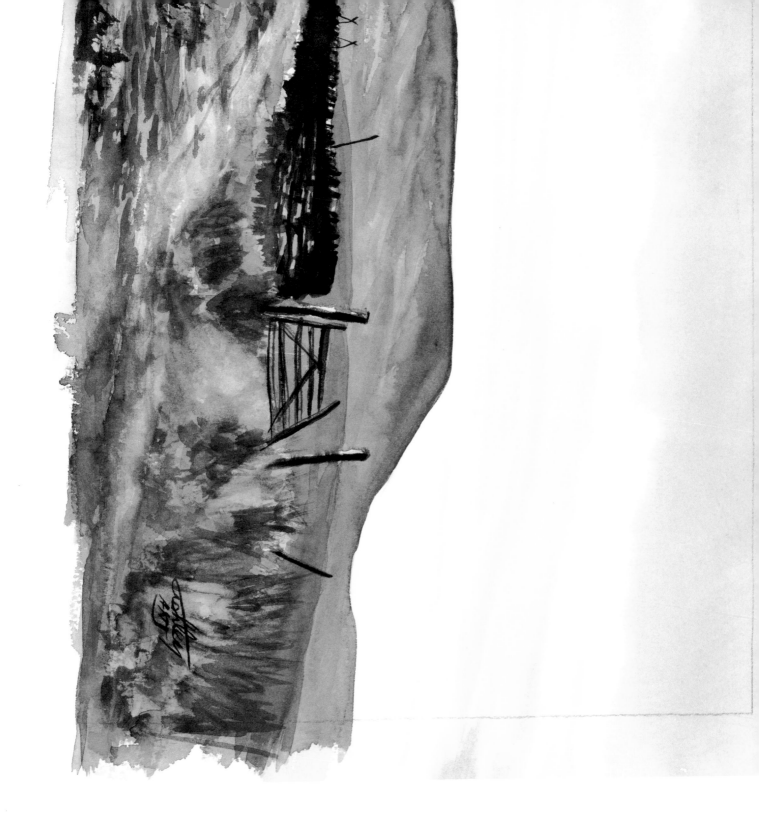

Pendle Hill

Witches Hill'. You will see that I have tried to capture the gleaming white building set against a stark sky. This was achieved by using a drawing pen, and then tinting the drawing with a sepia wash. I find that this medium is very useful when painting out in the open air. Try it for yourself, I am sure you will agree.

Figure 72 truly highlights the atmosphere that I felt hanging over Newchurch. The depth of this workout is brought about by the sharp lights and dark shadows that can be achieved with a monochrome. These monochrome sketches, when you are competent, should not take more than ten minutes. I have always told my students that the first piece of equipment to purchase is an alarm clock; then I recommend that they set themselves a time limit for working at their exercises, stopping at whatever stage they are at when the alarm triggers. If you try this exercise, you will find that you will learn to work at a speed which will develop over time and give your paintings a feeling of flow and rhythm. It prevents you from waffling, and adding details that need not be there.

Figure 73 I have named 'The Witches' Way'; it depicts a feature that is very characteristic of the North. In Yorkshire you will come across numerous gaps in the stone walls that are used as human gateways along the footpaths. They are narrow and steep so that animals are prevented from using them to stray from one field to another.

This five-minute lightning sketch 'All Up Hill', *Figure 74*, I named because wherever you go in this area, it is either up or down, the terrain being very hilly and steep in parts. Incidentally, because

of the terrain the roads are very winding and narrow, so drive with care and consideration, as in parts you will find that there is no room for cars to pass each other.

Figures 75a-c show you clearly what was going through my mind before I created my final painting of Pendle Hill. You will see in *Figures 75a and 75b*, two lightning sketches in pen. The final analysis of this composition is the larger and more detailed one, *Figure 75c*. I did these three sketches in order to help me construct my final painting, and I advise you to do the same. Never accept your first thoughts on composition; move your position and see if you can find a better construction in your mind's eye for that finished painting.

As you can see, my first thoughts on the composition of the painting changed slightly for the final one. My first idea had been to simplify the structure and make the view before me an impressionist painting. Then I felt that if I were to do this, I would have been hiding from the viewer the whole story, so the second thought that I jotted down was to add a bit more into the picture. You will note that in both of these sketches there is no direction of light. It is not until I have found the composition that I want to work with that I put in the direction of the light. In *Figure 75c* I knew that I had found my composition and I was ready to begin my final stage of painting the watercolour.

In *Figure 76* I used the colours Ultramarine Blue, Prussian Blue, Burnt Sienna and Lemon Yellow, as I find that these colours work well as my 'summer palette'. You will note the warmth in

the sky; at first you may think that I have used Raw Sienna, but it is actually a combination of Burnt Sienna and Lemon Yellow. Once you have developed the art of colour mixing, you will see that it very soon becomes second nature.

I wanted the path and the dry stone walls to lead the viewer's eye into Pendle Hill. However, I did not want the walls to lead one out of the picture as well. To prevent this from happening, I made use of the fences on the top of the walls, making them lean into the painting on the left-hand side, thereby directing the eye towards Pendle Hill. This is a good compositional tip when you are out painting views of apparently nothing, as it is very easy to use something, such as buildings and walls, to guide your eye into the picture and frame it.

In this painting, I have only used horizontals to form the composition, with the exception of the gateposts and fences. If I had not leaned the posts, or had any verticals in this composition, it would have given it an overall impression of being a colourful vanilla slice – so beware of horizontals.

Another thing to consider is that if in reality the gate had been closed and the barbed wire fence had continued, and I had captured it so, I would have created a painting that would have kept your eye and self out of the painting. I would have needed to use artist's licence and put in an open gate, bringing out the fence, to ensure that your eye would travel through the gap in the gate and begin to climb Pendle Hill.

You will note that Pendle Hill itself has quite a few green tints in it in my painting. To a beginner,

it would appear that I have used many shades to achieve this effect, but this is not the case. I have captured this barren hill using combinations of only two blues and one yellow. I have used the Prussian Blue with Lemon Yellow because it is a cold blue, and gives a jade green tone. Yet it still recedes into the distance, and does not crash over the foreground of this painting, a mistake that many students make.

The reason that Pendle Hill retreats into the distance is because I have used Prussian Blue. Prussian Blue retreats further, because it is a colder blue than say Ultramarine, which is a warm blue and originates from a different stable of blue colours. I have used Ultramarine Blue (with Prussian Blue and Lemon Yellow) for the mixes in the foreground, tinting over with Burnt Sienna.

The golden rule of colour perspective is to use warm colours in the foreground and cool colours in the distance. Reds advance and blues retreat. Use this as a rule of thumb when learning perspective colour. Because I knew about colour perspective, I was able to make sure that Pendle Hill did not jump into the foreground of my painting.

While I was down in the villages around the forbidding hill I had felt the presence of the witches, yet on the high plains of the Lancashire Hills I was at peace again and felt that they would be too. The only signs of human existence up there were the dry stone walls and fences. I titled this painting 'At Peace with Pendle Hill'. I am sure that, when you visit this area, you, too will experience the contrasting mood that surrounds the valleys of the area.

A FINAL WORD

What a dream this book has been for me – yet another chapter filled in my journey through my own book of life. I have never taken for granted the fact that I have been able to forge a career in what for me has been my vocation in life, painting, and every day I appreciate the fact that I have been bestowed with the greatest gift that anyone can have, and that is of health. These two gifts have given me a full and happy life and have enabled me to capture in watercolour the uplands and lowlands of this gem in the northern hemisphere, the British Isles.

Many a person, myself included, would have been contented with the experiences in life that I have already had, but to have been given the privilege and opportunity, by Boxtree, of taking up my brush and palette to journey the land in search of areas to paint has been an additional bonus in my life.

This book has taken well over a year to conceive. What has amazed me the most though is what an abundance of varying and contrasting landscapes this relatively small island has. Each of the locations in the book has its own character and personality and is beautiful in its own right.

This book has not only been an experience and challenge for me, but for my palette too. As you will know by now, my first love of painting lies with my beloved county of Yorkshire. My palette over the years has grown to understand her with her differing colours and moods, and I have been able to work in harmony with her. On this journey though I was stunned at how many times I had to change my palette, not literally as in introducing a new colour, as I said from the start that I was using only a limited palette on this trip. What amazed me was how many times I had to change the quantities of my ingredients, my colours, to enable me to adapt to the differing landscapes and colours found in my twelve chosen locations.

The experience that you achieve from painting out in the open air is something that you or I should never take for granted, and is second to none. Travelling the British Isles has been for me a sabbatical in the world of life and art. This journey has also enriched all of my senses, an enrichment that you will only be able to appreciate once you have made your very own journey. The memories I have of each of the locations will stay with me forever. I will never forget the feel of the biting wind blowing through my hair at Wrynose Pass, nor forget the smell of the salt sea air at St Ives, nature's music of wildlife beckoning me to Lindisfarne, or finally feeling the spirit of some of my greatest mentors, Turner at Richmond Hill and Constable at Flatford Mill. All these memories for me have been encapsulated into yet another set of treasures to add to my store in life, along with what I would consider to be a collection of some of my finest works created on this journey around the British Isles.

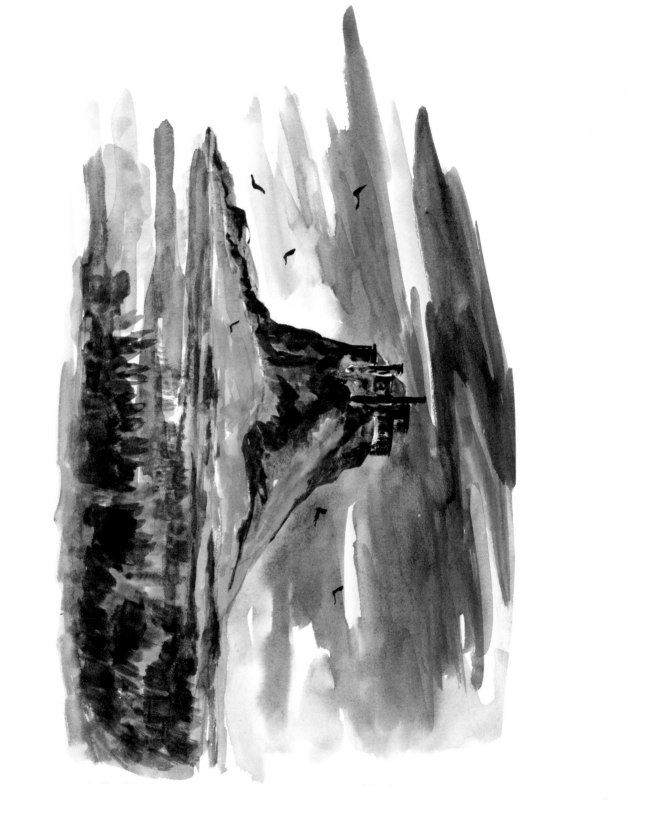

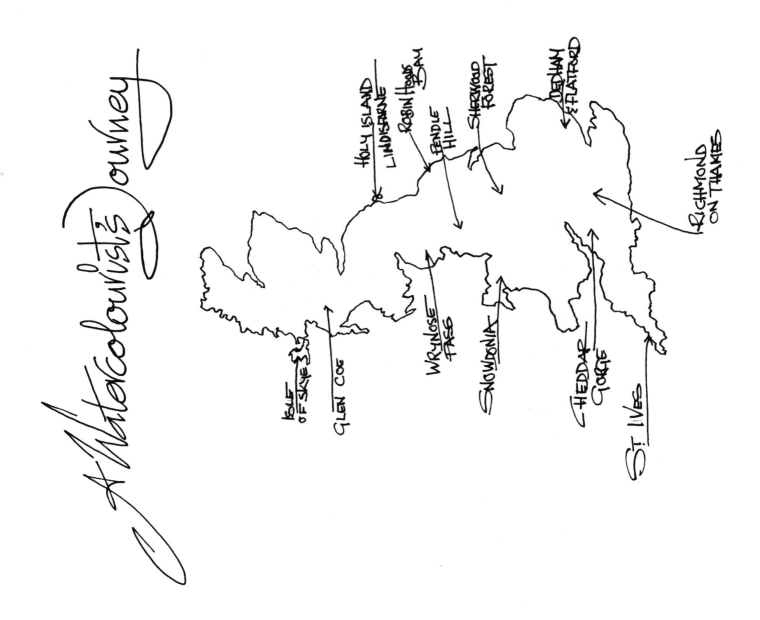

A Watercolourist's Journey

Isle of Skye
Glen Coe
Wrynose Pass
Snowdonia
Cheddar Gorge
St Ives

Holy Island Lindisfarne
Robin Hoods Bay
Pendle Hill
Sherwood Forest
Dedham & Flatford
Richmond on Thames